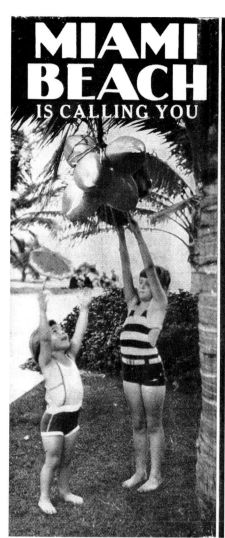

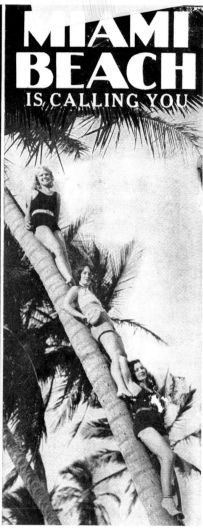

It was the worst Depression in the nation's history, and yet, for the 1930–31 season, Miami Beach was calling to people from all over an economically battered nation, enticing them to come to a land of sunshine, palm trees, happy children, fine schools and cheesecake. In Miami and Miami Beach, the depredations of the Depression were not only measurably less than in the manufacturing areas of the North and Midwest, but also, because of the mini-boom created by the building of the art deco hotels, there were jobs to be had on Miami Beach. So indeed, sunshine, stone crabs and cheesecake—and Miami Beach—are, once again, calling you!

SUNSHINE STONE CRABS AND CHEESECAKE

THE STORY OF MIAMI BEACH

SETH H. BRAMSON

Charleston · London

THE
History
PRESS

Published by The History Press
Charleston, SC 29403
www.historypress.net

Copyright © 2009 by Seth H. Bramson
All rights reserved

First published 2009

Manufactured in the United States

ISBN 978.1.59629.754.8

Library of Congress CIP data applied for.

Sunshine, Stone Crabs and Cheesecake is dedicated to two of Miami Beach's most revered families, both of them pioneers. Without the great works and contributions of the Galbut and Weiss/Sawitz/Bass families, the face of the city would be much different than it is today. The belief of both families in Miami Beach as a wonderful place to live, work and go to school has been evident for decades, and it is to Bessie and Hyman Galbut and their four sons and daughters-in-law; Jennie, Joe and Jesse Weiss; Jesse's daughter, JoAnn Bass; and JoAnn's son, Stephen Sawitz, that this book is lovingly and gratefully dedicated.

CONTENTS

PREFACE

Miami Beach is so unique, so different and such an incredible place that unlike almost every other place in the country where one can, through study and research, garner enough history and information to write about it, one cannot do so when writing about Miami Beach.

Legally, of course, one may write about anything he or she chooses, but to have "outlanders" or "flatlanders" (not that there are any mountains or even hills in south Florida, but you get the idea) try to write about Miami Beach (even those who grew up on the Miami side of Biscayne Bay can't and don't have the feeling for or understanding of what they are writing about) without having actually lived on and grown up there is, in the Yiddishism, "a *shanda*" for the neighbors. A *shanda* is, in effect, something to be ashamed of.

To write about Miami Beach—to *really* write about Miami Beach, to *truly* understand the place one is writing about—one must have lived on, grown up on, gone to school on and worked on Miami Beach. Only then can and does one have the true feeling and understanding of that incredible place, and it is that feeling and understanding that imbues the few who fulfill the four qualifications noted above with the background and knowledge of not only what growing up on Miami Beach was like but also what he or she is writing about.

The writings about the beach by a person who grew up on "the beach" are far more accurate and legitimate than the writings by one who did not grow up there. The four best examples of lack of empathy or feeling include four books on the history of Miami Beach, or its hotels, hospital or people, written by parties who were not only not from the beach but who also had nothing directly to do with what they were writing about, no real and true firsthand knowledge of the city, the people or the entities involved.

There is another major differentiation. Almost all of the photos in the books written by flatlanders have come from the usual suspects—libraries, museums and historical societies—while in this book, as well as in my earlier Miami Beach book and the two other books about the city written by people who also have the true and legitimate pedigrees to write about Miami Beach, most of the images emanate from private collections or other untapped sources. In this book—as in my first fifteen—more than 90 percent of the photographs have never before been published.

This is only the fourth book on or about Miami Beach and its history written by a person who was there, and it is the second by this writer. One of the other two was written by Michele Oka Doner and Mickey Wolfson, and it is a wonderful and beautifully illustrated story of growing up in "the world's playground," primarily because Michele and Mickey are "Miami Beach people." The other is disgraced former mayor Alex Daoud's book about illegal and unethical activities and behavior on Miami Beach, and whether one agrees with or likes the content or the author, the fact is that Alex fulfills the four qualifications necessary to write a book on and about the beach.

It should also be noted that there are several individuals and institutions who either do not appear at all in this book or appear only minimally or peripherally, and I want to make it totally and completely clear that this is because those people or organizations (four, in particular) either ignored my entreaties for their participation or acted so reprehensibly and irresponsibly that their actions, either individually or on behalf of those organizations, were nothing short of foolish and shameful. Names? We don't need no stinking names! They—and I—know who they are.

A great many books and articles have been written about the city going back to the 1920s. Some were well done, some were fair and some were riddled with errors. But to really write about Miami Beach, to write about it with feeling, understanding and even compassion, one must know or have known the people and places he or she is writing about, and not just by having looked up some questionable "facts" on *Wikipedia* or even in some more respectable sources (see the example in chapter four of the error-filled article about Lincoln Road's history).

Sadly, though, it is not just the writing that is often without validity. Too many of the "walking tours" are laden with inaccuracies, nonfactual remarks purporting to be true and made-up nonsense that may sound good but is without basis in truth or fact. And it is the same with too many of the articles and books written about Miami Beach, the authors of which, after a couple of years of living in "the sun and fun capital of the world," decided that

they knew enough about the city to write whatever it was that they wanted to write. They didn't, and in too many cases, the sophomoric writing and total lack of factual knowledge is appalling.

So from someone who lived on, grew up on, went to school on and worked on Miami Beach, I certainly hope that when you finish reading this volume, you will agree that one must have fulfilled the four qualifications noted above before he or she can (or should) write about Miami Beach. If I have done my job, this book will prove that to you.

ACKNOWLEDGEMENTS

I am indebted to no few people who offered thoughts, insights and items for inclusion in this book. First, the two families to whom this book is dedicated must be warmly noted, for without the Galbut and Weiss/Sawitz/Bass families this book might not have been.

Great thanks are extended to Bennett Bramson, who has been, for our now more than fifty-seven years of brotherhood, like a Rock of Gibraltar with his belief in, and support of, his only sibling. My friend Quentin Sandler unhesitatingly opened his and Sydelle's family albums for my use, and their daughter, Gail Reiss (Beach High 1967 Coronation Queen) was incredibly helpful, as was her—and now my—friend Darryle Pollack. Diane and Aristotle Ares shared their memories and photos of Miami Beach during many meetings and discussions. Ron Jayson, Beach High '66, now in Atlanta, provided some fine material on the Amsterdam Apartments, the Famous Restaurant and Temple Kneseth Israel. Hannah (Diamond) and Al Lipton, June and Stu Jacobs, David ("Chicky") Rogers, Ann Broad Bussel, Mickey and Sherman Tobin, Joyce and Buddy Grossman, my favorite diva Barbara Courshon (Beach High 1962 Coronation Queen), Luba Kirsch, Jeff Weisberg, Stuart Jacobs, Barbara and Barry Sugerman, Patsy and Alan Glaser, Dr. Judith Berson-Levinson, Lawrence Gaisin, Michael S. Goldstein, Judy Malschick, Ron Silvers, Caryl and Dr. Harold Unger, Cecile and Herb Pagoda, Audrey Sweet, Stephen Cypen, Laney Sheldon and Shelley Adelman all gave or loaned me marvelous images or provided information. City of Miami Beach assistant city clerk Liliam Hatfield, who has, along with all of her other work, dedicated herself to preserving Miami Beach's history, graciously opened the city's photo files to me and offered her thoughts and input throughout the writing of this tome.

ACKNOWLEDGEMENTS

As always, Sara Leviten, Miami researcher and historian, unhesitatingly shared facts and information. Dr. Abraham Lavender, founder of the Miami Beach Historical Association, was, as usual, completely supportive of this project. Steve Hertz provided information on his dad, Hal, and Deborah Desilets was unceasing in her efforts to see that I included Morris Lapidus in the book, while Ann Rabinowitz loaned me superb photos of her dad and uncle at Bern's Drugs. Former North Miami Beach judge and Miami Beach mayor Harold Rosen, in between the laughs, managed to ferret out a number of wonderful images for my use. Miami Beach VFW Post 3559, on West Avenue, proved a treasure trove of information, and I salute its members warmly for their help. Myra and Steve Redman generously loaned me their family albums and provided information on Steve's dad, Ray, and all he did for Miami Beach, previously without acknowledgement.

Myriam Citron, executive assistant to Russell Galbut, deserves special thanks. Noodging her endlessly for information on and about the Galbut family neither rattled nor annoyed her, and her kindnesses were endless. My sincere thanks are warmly extended to her.

With today's modern technology, computer non-nerds such as myself are always beholden to those who provide twenty-first-century support, and as with my *L'Chaim!* and *Aventura* books, I am very indebted to Adam Rogers, the wonderful young man who does my scanning and computer detailing. So to Adam, and all who were of such great help, and to quote the inimitable Keith Olbermann, "Great thanks, Sir!"

Unless otherwise credited, all photographs are from The Bramson Archive, collection of Myrna and Seth Bramson.

INTRODUCTION

T he story of Miami Beach has been told no few times. Some of those tales have been intriguing (Polly Redford's *Billion-Dollar Sandbar* a prime example), and one (*Miami Beach in Rhyme*) was marvelously unique in that it told the reader about Miami Beach in a series of poems. Yet another, *The Miracle of Miami Beach*, was written by Miami Beach's first mayor, J.N. Lummus. It is possible, though, that Charles Edgar Nash's *The Magic of Miami Beach*, published in 1938, just twenty-five years after the city's incorporation, may have been the first. Each of those volumes was, to quote a beloved personage, "fascinating!"

It is possible—even likely—that more words have been written about Miami Beach—its people, politics, hotels, restaurants, clubs, schools, streets and homes—than about any other place or city of its size in America. But this book is unlike any of the others, including my previous *Images of America: Miami Beach*, because once the formalities of chronology are dispensed with, this book moves on to a Miami Beach that most people have not thought about for years and, in many cases, have never seen: views and scenes of various streets; of and from the churches, temples and schools; and of the clubs, restaurants, hotels and businesses. In short, this book is not just about the history of the city but also the history of everything that contributed to its becoming what it is today, including so many of the people.

Even casual Miami Beachphiles are aware of the city's beginnings, starting with the arrival of the Lums in 1870, and while Miami Beach's most famous pioneer names—Field and Osborne, Collins and Pancoast, the Lummus (Lum-miss, NOT Loom-miss) brothers, Carl Fisher, John Levi, Pete Chase, Henri Levy, Claude Renshaw, Steve Hannagan, Avery Smith, Dan Hardie, Jenny and Joe Weiss—readily roll off the tongue, this book focuses on those who have been previously overlooked. Indeed, names such as Bessie and

Hyman Galbut and their four sons; Jesse Weiss, his daughter JoAnn Bass and her son, Steve Sawitz; the Tatum brothers; Hank Meyer; James Allison; and a multitude of Miami Beach "characters" will be brought to life so that readers may understand what they did to build a great city.

The original visions of what the island across Biscayne Bay from the mainland would be used for included coconut, papaya, avocado, truck (produce) and citrus plantations—none of which, ultimately, were successful—and it would only be Carl Fisher's faith in himself and his ability to build a city that would begin the evolution of what had been called "East Miami," "Altonia," "Alton Beach" and "Ocean Beach" into what it is today.

The Jewish influence on the life of the city becomes important beginning in the 1920s with the opening, in 1921, of the first Jewish-owned hotel, the Nemo, at First Street and Collins Avenue. Prior to the construction of Miami Beach's first temple, Beth Jacob, which opened in 1929 at 311 Washington Avenue, services were being conducted on the third floor of the David Court Hotel, at 56 Washington Avenue, likely beginning sometime in late 1927. Additionally, the part that Miami Beach High School and the Hebrew Academy played and plays in the life of Miami Beach is looked at, along with the misguided thinking that allowed an untoward number of the city's clubs and hotels—some of them into the 1970s—to exclude Jewish patrons with advertising that included such couched phrases as "Restricted Clientele" or "A guest list that is suitably restricted" in their advertising.

The range of hotels, clubs and restaurants was astounding for a resort city that effectively shut down from mid-April through early December almost from its beginnings until the early 1950s. The effect on the freestanding nightclubs of the introduction of the modified American plan (two meals daily included with the room) by so many Miami Beach hotels—and, later, the effect of the high-rise apartment houses and condos on the hotels—will also be noted.

Sunshine, Stone Crabs and Cheesecake is not just about the history of Miami Beach. It is also about the life and times, the ups and downs, the reinventions and the rebirths of one of the greatest resort cities on earth and a city that is today one of the world's hottest destinations.

Besides the immense resource that is my collection (the largest private collection of Greater Miami/Miami Beach memorabilia in America), numerous other entities and individuals were called upon to participate in this effort, and almost all of them did so warmly and willingly, giving the book a singular cachet for its uniqueness and originality.

So sit back, relax and join me for a trip through time, nostalgia and memories as page after page brings back thoughts and images of a place that, while it certainly has changed, continues to exert a powerful hold on anybody who has ever lived on or visited it. To this day, there is nothing and no place like Miami Beach, Florida.

BCF
(BEFORE CARL FISHER)

What was it like before the commercial era arrived? The word "paradise" comes readily to mind, but the fact and truth is that while there was certainly an element of romance and intrigue to that beautiful and not insubstantial sandbar (technically, Miami Beach is actually one of the most northerly of the islands that parallel the lower east coast of Florida and continue all the way southwest to Cayo Hueso—Key West), it was covered with inhospitable flora and potentially deadly fauna, well removed from being a paradise.

It was, however, of enough interest to Henry Lum and his son Charles, who, sailing northeast from Key West on that fateful day in 1870, spied an intriguing looking beach on a large mangrove sandbar/island along the lower mainland and decided that it would be a fine spot to land their boat. Interestingly, and for whatever reason, neither the city's files nor the existing Miami Beach histories state the exact date upon which the Lums first stepped onto the sand from their sixteen-foot sailboat.

While we do know that the Lums originally hailed from Sandusky, Ohio, the records are unanimous in their statements that, following their exploration of the lower east coast of Florida, the men returned to their home in Red Bank, New Jersey, whereupon they purchased a sizable piece of the sandbar/island from the State of Florida (most of which would later become the Ocean Beach development) for—are you ready?—thirty-five cents an acre!

When the Lums returned twelve years later, they were accompanied by Ezra Osborn and Elnathan T. Field, of Middletown, New Jersey, whom they had interested in the venture of operating a coconut plantation on the island. Having formed a joint venture with another Jerseyite—David Baird—

Osborn and Field, to protect themselves against possible future competition, purchased a strip of land along the oceanfront from Cape Florida to just above Jupiter (in today's Palm Beach County) for the price of between $0.75 and $1.25 per acre. Eventually, Osborn and Field would buy out the Lum holdings, giving them a sizable profit above their original investment cost, the former paying the latter $0.75 an acre for their land, more than doubling the Lums' initial investment.

With an immense amount of effort, along with provisions, boats formerly used for lifesaving along the New Jersey shore and twenty-five men brought with them to begin the clearing of land, the partners set to work. Without going into agonizing detail, it should be noted that the rabbits, rodents, squirrels, possums, skunks, foxes and other voracious woodland creatures made short work of the 334,000 coconut sprouts, of which approximately 155,000 were planted on the island on the east side of Biscayne Bay.

Osborn and Field, though still hopeful, had exhausted their cash on the project and returned to New Jersey to seek out other investors. Fortunately for them, they interested John S. Collins in the benighted effort. The Lums, in the meantime, were able to convince New York businessman Henry Robinson that it would be both expeditious and profitable for him to invest.

Although Robinson is mentioned as an investor in both Lummus's and Nash's books, no further comment is made regarding either Robinson or Baird, who was noted in Nash's book. The involvement of Robinson and Baird, other than as money lenders, seems to have simply slipped from the pages of history.

After Collins advanced Field $5,000, Osborn, in 1907, sold Collins his share of the property, and Collins became Field's partner. Collins had first come to the Miami area in 1896, shortly before the Florida East Coast Railway (FEC) brought its first train to the shores of Biscayne Bay. Though Collins noted with some dismay the destruction of the coconut plantation, he still had faith that the island would provide a marvelous setting for the planting of tropical fruits, including avocado and papaya, as well as vegetables, among which were corn and potatoes.

By 1909, Elnathan Field foresaw a second disaster, and Collins, to his great delight, purchased Field's holdings, making him (Collins) the sole owner of 1,670 acres of waterfront land, four and a half miles along the Atlantic shore and one mile fronting Biscayne Bay. Although Collins's sons, Arthur, Irving and Lester, came south from New Jersey to "look over" the situation, it was his son-in-law and partner in the Collins and Pancoast Supply Company of Merchantville, New Jersey, Thomas J. Pancoast, who took the lead in confirming the older man's belief in the island.

The Story of Miami Beach

Alarmed at the amount of family money being spent on what Pancoast at first thought was a boondoggle, in 1911, he came down to visit the Ocean Beach farm and to humor the old man before bringing him home. But it was Pancoast and the Collins sons who saw the light, confirming and concurring with Collins's assessment that the island was a farming paradise and agreeing with his idea of building a canal across Ocean Beach to cut the shipping distance to the Miami side by close to one-third.

By that time, the Biscayne Navigation Company, owned by Avery Smith and his partner, James C. Warr, was, with no minimal sense of humor, operating two fifty-five-foot-long ferry boats, *Mauretania* and *Lusitania*, across the shallow, three-mile-wide bay. Passengers and parcels were brought back and forth on the ferries, but it is quite possible that the eighteen carloads of red bliss potatoes that were grown on what by then was called Ocean Beach and shipped from the FEC freight depot in Miami in early 1912 were brought to the Miami side by other, likely larger, vessels than the ferries.

Three bathing casinos had been built facing the ocean, one by the Ocean Beach Company, one by Dan Hardie, who would later be Dade County sheriff, and one, known as Cook's, at what would become Fifth Street that outlasted the other two. The Ocean Beach Casino was purchased by Avery Smith in 1908, and it was he who, in 1913, hired a young fellow by the name of Joe Weiss to be his cook; the rest of that story follows in chapter three.

By 1912, Collins and Pancoast realized that, with the coming of the automobile, they needed to provide road access to Ocean Beach and, after overcoming the opposition of the Navigation Company, set out to build, at a projected cost of $100,000, what would become the longest wooden bridge in the world.

The bridge, which started on the Miami side from what is today's Northeast Fifteenth Street, was surveyed to cross the open bay, move onto solid land for the short distance across Bull (later Belle Isle) Island, jump across a relatively narrow water gap and reach Ocean Beach at what is today's Dade Boulevard.

Unfortunately for Collins and Pancoast, their contracting company ran out of money and was forced to close down, the bridge only half completed. Dejectedly, and unsure of where to turn, they returned to New Jersey, praying for some kind of a miracle that would allow them to complete the project. As fate would have it, a yacht broker, along with a marketing genius who was an inventor and a great promoter, would be their salvation.

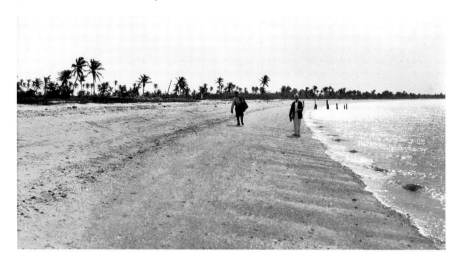

On the beach at Ocean Beach. Mostly deserted, visited only by adventurers or excursionists from the mainland, this strip of sand would eventually become Miami Beach. (The identities of the two men are unknown, although it has been suggested that Thomas Pancoast might be at left, with John S. Collins at right.)

Although the exact location of this image is unknown, it is likely at or near the Ocean Beach ferryboat landing on the west side of the island, close to today's Biscayne Street.

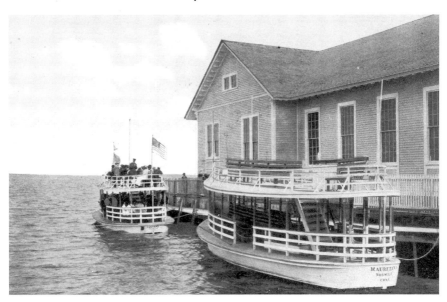

Leaving the Miami side from Elser's Pier at the foot of Twelfth (later Flagler) Street, the Biscayne Navigation Company's ferries did a surprisingly robust business, carrying large numbers of adventuresome visitors across the bay to the pier at the south end of Ocean Beach. In this very rare view, both ferries are visible: the forward boat, *Lusitania*, just getting ready to cast off, while the *Mauretania*, closer to the camera, is empty, apparently awaiting the next load. The boats had a second floor, which was equipped with benches, and were owned by Avery Smith (of the casino of that name) and James C. Warr.

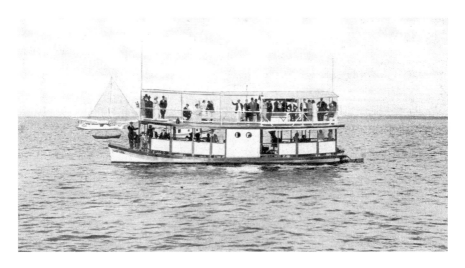

It is possible that other operators besides Biscayne Navigation Company connected Miami to Ocean Beach, although records are sparse. It is, therefore, a matter of great joy when a previously unknown image appears, in this case a view of the *Lady Lou* en route between the island and the mainland.

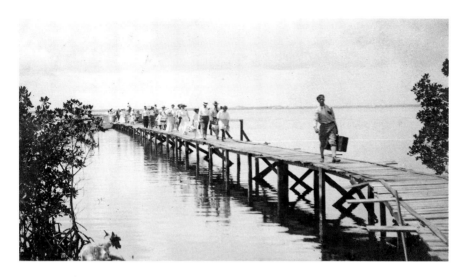

This absolutely incredible image—one of the few known to exist showing the Ocean Beach pier—was made in 1908 and includes beachgoers disembarking for a day on the island, which was still in a mostly pristine state and under cultivation by Field and Collins.

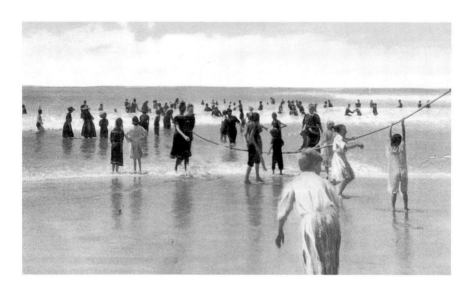

A marvelous 1908 view of the bathing attire of the day, photographed on the beach somewhere below today's Third Street.

The Story of Miami Beach

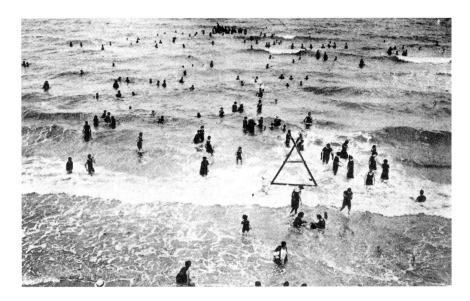

In the early years of the twentieth century, beachgoers enjoyed a day in the surf and bathed but did not swim, at least as the term is used today. The early Ocean Beach casino operators provided safety ropes for the non-swimming bathers—the triangular shape visible just right of center in the foreground with an A-frame near the top to carry the rope.

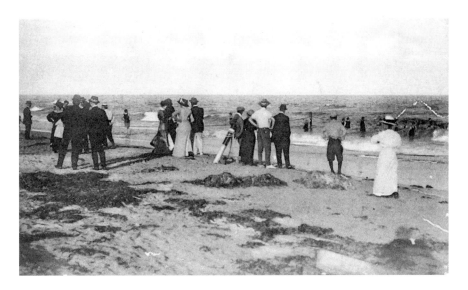

On an Ocean Beach laden with seaweed, December visitors disinclined to enjoy the waves sport their Sunday best as they observe the hardy oceangoers in a place that most of the nation was still blissfully unaware of. Not one of the beachsiders in this image is hatless!

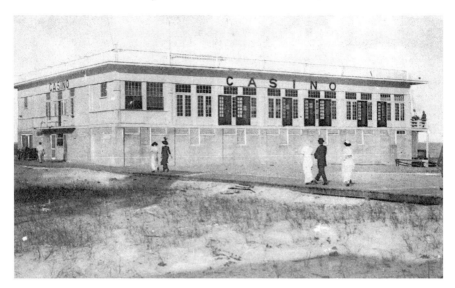

The Ocean Beach Amusement Company's Casino was built right on the beach. Visitors could rent a locker and a (wool) bathing suit, enjoy a snack or lunch and bathe. Several years after opening the Casino, the company added a swimming pool with a high-diving board on the north side of the building.

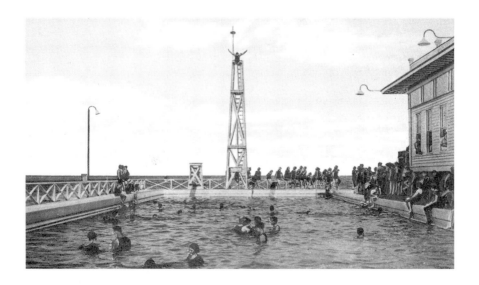

A view of the Casino swimming pool shows a diver just leaving the high board.

The Story of Miami Beach

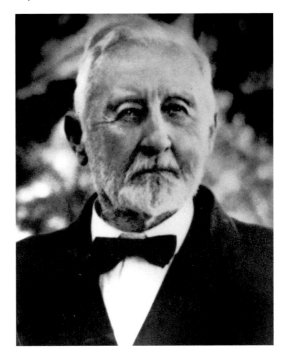

Born on December 28, 1837, in Moorestown, New Jersey, John S. Collins was close to seventy-five years old when this picture was taken in 1912. When Collins died on February 11, 1928, he was more than ninety years old, and the sandbar/island that he first saw in 1896 was unrecognizable. Although Carl Fisher would be the builder of Miami Beach, it was because of John S. Collins that Fisher's recognition and reputation were far greater than just an association with the automobile and road-building industries. *Courtesy City of Miami Beach.*

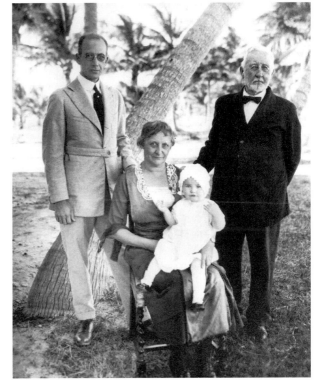

Taken in 1921, this photograph shows John Stiles Collins at eighty-three-plus years young, with his son-n-law and daughter, Mr. and Mrs. Thomas J. Pancoast, and, it is believed, the Pancoasts' granddaughter. Pancoast, born in 1865, became Miami Beach's second mayor, succeeding J.N. Lummus. Pancoast served in that post from October 1918 until October 1920. He died in 1941. *Courtesy City of Miami Beach.*

Shown in the process of being cleared, this is what the Lums, Osborn and Field, Collins, Pancoast and Fisher faced as they began to transform a large sandbar/island from a wilderness first into farmland and then into a great city.

THE CARL FISHER YEARS

This book is not meant to be a biography of Miami Beach's founder. But to understand why, as the memorial to him at Fifty-first Street and Alton Road is inscribed, "He Carved a Great City from a Jungle," a few brief comments are in order.

There have been several stories relating to Carl Fisher's (January 12, 1874– July 15, 1939) involvement with Collins and Pancoast. With slight variations, however, each of them, whether in Jerry Fisher's *The Pacesetter* (Jerry is a distant relative), Jane Fisher's *Fabulous Hoosier* (Jane was Carl's ex-wife) or Lummus's or Nash's books, seems to coincide with the sale of a yacht to Fisher by John H. Levi, a yacht broker and marine engineer from New Jersey who represented Seabury Shipyards in New York City and who oversaw the building of Fisher's yacht, which Levi accepted delivery of in Cairo, Illinois.

Fisher planned to take the boat for a leisurely cruise down the Mississippi, into the Gulf of Mexico, around the Florida Keys and up the east coast of Florida. After several difficulties during the shakedown voyage, Fisher elected to debark from the cruise at Mobile, leaving the yacht with Levi for shipment by rail to Jacksonville. Railroad bridge clearance problems precluded the large ship from being sent that way, so Fisher, en route back to Indianapolis, instructed Levi to complete the trip by water, taking the boat to Jacksonville. As fate would have it, that would not happen.

Levi, upon reaching Miami, was so enthralled with the then-small town that he elected to stay, wiring Fisher to join him in what was already being called "the Magic City" rather than in Jacksonville.

Stories have been told to the effect that Fisher met Collins and Pancoast through Levi in New Jersey, but those stories have been shown to be incorrect: Fisher met Collins on Ocean Beach early in 1912 and learned about the stalled bridge project at that time. He returned to the Miami side to tell his

wife, Jane, that "that little Quaker (Collins) is the bravest man I have ever met. Imagine, Jane! Imagine starting a gigantic project like that bridge at the age of 75—when most men are ready to sit down and die!" As she recounts in her book, Jane knew then that Carl, the brains behind Prest-o-Lite and the builder of the Indianapolis Motor Speedway, had found a new challenge.

Once again, there are slight variations in the story of how Fisher obtained the land that would, in 1915, become Miami Beach, but essentially, the facts are that Carl agreed to loan Collins $50,000 to complete the bridge and in return Collins gave Fisher 200 acres of beach land one mile long and eighteen hundred feet wide from the ocean to the bay. Fisher then purchased an additional 260 acres, including 200 acres that he bought from the Collins and Pancoast–owned Miami Beach Improvement Company, which they had formed in 1911.

The incredible story of Carl Fisher has been told in three books dedicated to him, in each of the Miami Beach histories (legitimate and otherwise—refer back to the preface for an explanation) written through the years and in numerous articles, hence it is not necessary to provide yet another lengthy discussion of his life here. However, there is an as yet untold chapter in the Fisher saga that is being put in print, on these pages, for the first time ever.

While each of the Fisher biographies does mention his longtime friend and partner in Prest-o-Lite and the Indianapolis Speedway James A. (Jim) Allison (August 11, 1872–August 3, 1928), there is little further discussion of the man who was Carl's silent partner in Miami Beach. Fisher's share of the 1910 sale of Prest-o-Lite to Union Carbide was, according to Jerry Fisher, more than $5,633,000, and that, in those days, was, to paraphrase the late Illinois senator Everett Dirksen, "some real money." It is likely that Allison received about the same amount.

According to Allison's great-great-niece Sigur Whitaker, of Norfolk, Virginia, Allison and Fisher were exact opposites and played off each other perfectly; Jim being the quiet, behind-the-scenes guy and Carl being the promotion-minded, publicity-seeking front man. It worked like the proverbial charm as each did his own thing completely complementarily to and with the other. Ms. Whitaker was able to provide not only the names of Jim's and Carl's partners in the Speedway but also the percentages of each owner: Jim and Carl jointly owned $62\frac{1}{2}$ percent; Frank Wheeler, 25 percent; and Arthur Newby, $12\frac{1}{2}$ percent.

Whitaker's factual details include the information that Jim Allison began coming to Miami Beach in 1915 or 1916. In 1919, he began construction of the Miami Aquarium and Laboratory, located on the Miami Beach side of the County (later MacArthur) Causeway. The very few images known to exist show the facility on the north side of the east end of the causeway, where a Gulf gas station would later be built with fishing docks behind it. Opening on January 1,

The Story of Miami Beach

1921, it closed just two years later, in April 1923, a financial failure. During that same year, Allison became president of the Speedway, and in 1925, dissatisfied with the treatment he had received during a hospital stay in Palm Beach, he determined that he would build a hospital in Miami Beach, as well as a home on Star Island, one of the three islands reached via the County Causeway.

What has been essentially unknown up until this point, according to Ms. Whitaker, is that during the building of Miami Beach, for which Fisher has rightfully received the largest amount of credit, his silent but almost equal partner was Jim Allison.

It was, therefore, logical that when Jim told Carl that he wanted to build a hospital (known first as Allison Hospital), Carl gave Jim the land, a spoil island now known as Allison Island, as the site for the projected hospital. In addition to a large estate on Star Island, where he lived until his death, Allison built his hospital, spending $3.6 million on the construction. Opening on January 1, 1926, the building was turned over to the management of the Sisters of St. Francis in 1927. In 1929, they purchased the facility and changed the name to St. Francis Hospital. In 2004, Miami Beach developer Craig Robins purchased the eight-and-a-half-acre site from the Sisters, who had decided to end their operation of the longtime Miami Beach institution, for $12 million. Robins has since redeveloped the island into a private, gated residential enclave; the remainder of Allison Island, on the north side of Sixty-third Street, remains, as it has been since it was first given to Allison, a street of beautiful single-family homes.

Fisher would, as the world knows and as his memorial at Fifty-first Street and Alton Road on Miami Beach states, "create a great city from a jungle" before he lost interest in the city he envisioned and built. Retaining a home in Miami Beach, he moved on to his fateful and destined-to-fail project of building a northern clone of Miami Beach at Montauk Point at the eastern end of Long Island. Falling victim to alcoholism and becoming ever more reclusive, Fisher died of a gastric hemorrhage in St. Francis Hospital on Allison Island late in the afternoon of July 15, 1939.

Near bankruptcy, having sold and mortgaged almost all he owned in Miami Beach to build Montauk, he was only sixty-five and a half, ten years younger than John Stiles Collins was when Fisher first met him. Without going into paroxysms of glorification, it is safe to say, when talking about Carl Graham Fisher, that not only is the city of Miami Beach his monument but that he was also, and always will be, the greatest single name in the history of the city. Carl Fisher was and is and always and forever will be the one and only (no matter what anybody else, living or dead, wants to claim or call themselves) "Mr. Miami Beach."

The Ocean Beach Realty Company published a series of now incredibly rare postcards, including this and the two images that follow. Interestingly, the same three men shown in this postcard are also shown on another card in the series. In this view, one of the few known to show the O.B. Realty Company's office, which is on the left, the caption tells us that the road is being constructed to connect with Miami; the problem is that it is unclear if this is what would become Collins Avenue or Alton Road. It is not what would later be Dade Boulevard.

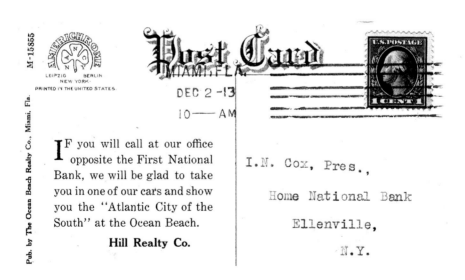

Apparently, Hill Realty Co., signee of this O.B. Realty Company card, was a sales agent for the developer. Even then, the reference to the "Atlantic City of the South" at Ocean Beach was an example of the hyperbole that would typify Miami Beach publicity for the coming century. The card was issued following the opening of the bridge, given the statement that "we will be glad to take you in one of our cars."

The Story of Miami Beach

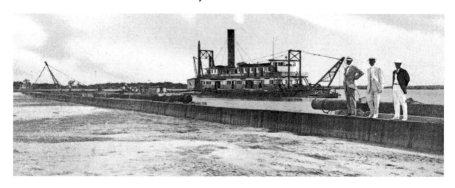

The three men referenced earlier are standing on the sea wall on the bay side of Ocean Beach, with the dredge *Davis* in the background. While it is uncertain who the men are, it is likely that they are Collins, Pancoast, Fisher, Levi or one or more of Pancoast's sons.

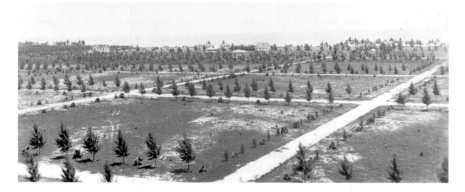

After the filling was completed, the ground was seeded and Australian pines (still the centerpiece of Pinetree Drive) were planted, this circa 1917–18 view looking east was made. Seven homes are visible.

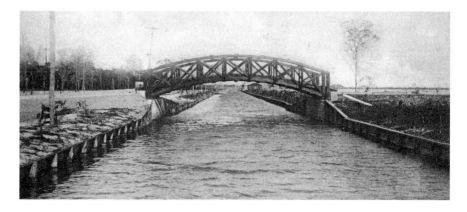

This marvelous view of the then recently completed Alton Beach (later Collins) Canal was most likely made at what is today Alton Road and Dade Boulevard. The bridge was almost certainly a project of the Alton Beach Realty Company.

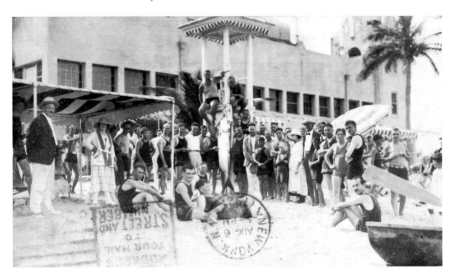

Photographed in August 1921, it is likely that this group is at the St. Johns (Fisher) Casino. That building, located between Twenty-second and Twenty-third Streets on the east side of Collins Avenue just south of the Roney Plaza, would later be called the Roman Pools and then the Everglades Cabana Club. After being closed sometime in the 1950s, it remained vacant until it was torn down and replaced by a Holiday Inn in the late 1960s.

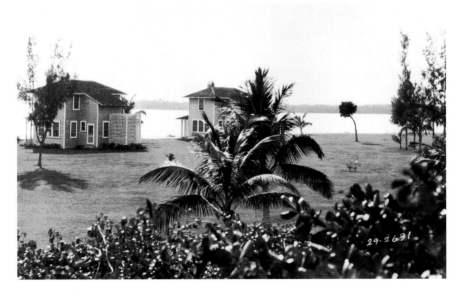

From the collection of the late Pete Chase—Fisher's sales director, longtime Miami Beach resident, founder of the chamber of commerce and for whom Chase Avenue is named—comes this photograph of two of the early Miami Beach homes, both wooden. As with so many of the views that came from Chase, there is neither a location nor a date shown on the back of the photo.

The Story of Miami Beach

Cheesecake! Oh, how we loved and love cheesecake! And it didn't and doesn't matter whether it was the marvelous Joe's Broadway, Al Nemets, Wolfie's, Junior's, Rascal House or Pumpernik's confectionery-like dessert made with real cream cheese or the Steve Hannagan–created imagery of beautiful girls romping, standing or lying on Miami Beach, for either was and is cheesecake!

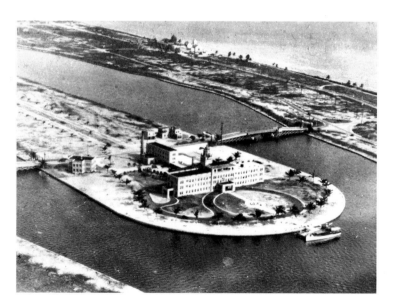

Another marvelously rare Miami Beach photograph: every building shown on Allison Island is part of the hospital, still carrying Jim Allison's name. The bridges over the waterways were wooden, and the only building standing in this scene, other than the hospital, is the Deauville (later MacFadden-Deauville) Hotel, upper left.

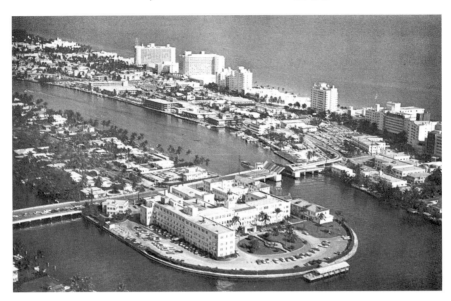

Above: For purposes of contrast, a circa 1958–59 view, taken from approximately the same location, is shown.

Right: "Our Founder," Mr. Miami Beach (there is not now nor will there ever be another) Carl Graham Fisher, photographed in 1919, in his prime.

This page and next: A great sportsman, Carl, astride the white horse at far right, so loved polo that he built fields for the sport in front of the Nautilus Hotel, at Forty-third Street and Alton Road, containing all of the area from today's Forty-first Street and Alton north to Forty-sixth Street and west to Meridian Avenue, including what is now Nautilus Middle School at Forty-third Street and North Michigan Avenue. Additionally, he was an avid golfer and a fairly decent tennis player. He is shown standing in the indoor tennis court facility that he built at James Avenue and Lincoln Road, today the site of the Albion Hotel.

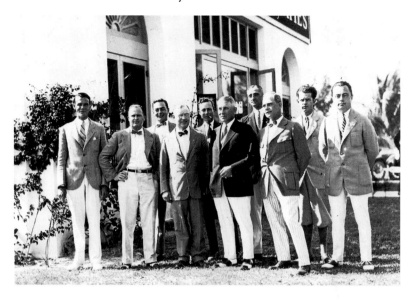

The Fisher Properties sales team—a rather rakish looking group of lads—in front of the company office building at 1000 Lincoln Road, today the location of the Van Dyke Café.

Fisher built the Coco Lobo Cay Club on an island in south Biscayne Bay as a place to entertain his invited guests, including the Committee of 100. Fisher, although reticent at times, was a great schmoozer, raconteur and storyteller. Here, ever-present cigar in mouth, he practices his art at the club with friends E.A. (left) and W.V. Hughes.

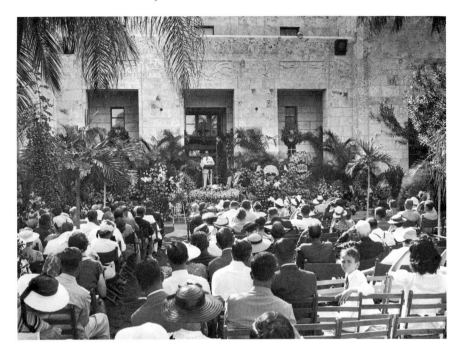

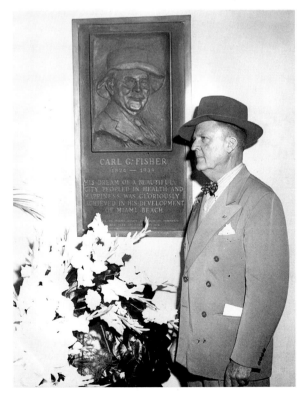

Above: John Oliver LaGorce, Fisher's close friend and the developer of LaGorce Island, gave the eulogy for Carl in front of the then Miami Beach Public Library in Collins Park between Twenty-first and Twenty-second Streets on Collins Avenue. A sorrowful crowd gathered to pay homage to Miami Beach's builder on a hot July 1939 day. Only a young Moishe Poopick is looking back toward the camera.

Left: Paying tribute to Carl at the city hall plaque dedicated to him is Fisher's longtime friend and colleague Pete Chase. The plaque was moved to the new city hall on Seventeenth Street when that building opened in the late 1970s and holds a place of honor in the building's lobby.

IT'S JOE'S STONE CRAB—NOT STONE CRABS—RESTAURANT

Oh my god, who knew? Well, you know now, and let's not make the same mistake again, because the name of Florida's oldest—and, as far as most authorities state and agree, its best—restaurant is NOT Joe's Stone Crabs. It's Joe's Stone Crab. Singular, as in one, not plural, as in more than one. Obviously, I'm partially funnin' ya here, but the fact of the matter is that Florida's—and one of the nation's—best (in terms of food, service and cleanliness) restaurants just happens to be (what a blessing!) in Miami Beach. And its name is Joe's Stone Crab Restaurant.

It's not, of course, a real or genuine issue, except that JoAnn Bass, of the incredible family dynasty at 11 Washington Avenue, really would like everybody to use the proper name. But for those coming to one of America's greatest food emporiums, it's not a concern: "Where are we going for dinner?" "Would you like to go to Joe's?" And the answer, invariably and unquestionably, is always the same: "Really? Seriously? I would LOVE to go to Joe's!"

Miamians are not worried about singular or plural, but they know that a visit to the managed-by-the-same-family-for-ninety-one-years institution, which they usually refer to simply as "Joe's," is always going to be nothing short of great. And unlike many restaurants in Florida that are living on past laurels (particularly two in Tampa), Joe's laurels are enhanced daily, for its management practices the absolute fundamental and basic principles of the food and beverage business: great food, excellently served in magnificently clean surroundings by gracious and cordial servers. Simply put: while there certainly are some pretty good restaurants in Florida, only one is *the* best—and that one is Joe's Stone Crab Restaurant.

But how and when did it really begin, you ask, and why is there a chapter in this book devoted to one restaurant? The answer is simple: because Joseph Weiss—the "Joe" of Joe's Stone Crab—likely with his beloved wife, Jennie, in tow, probably began taking the ferry from Elser's Pier at the foot

of Twelfth Street on the Miami side over to the pier at the foot of what would eventually become Biscayne Street on the Ocean Beach side as early as sometime in 1913.

On one of those fine Miami days, Joe crossed Biscayne Bay and walked over to Smith's Casino, where he sought out its owner, Avery Smith. Weiss told Smith that not only was he a marvelous cook but also that his cooking would bring people in, and since Smith had competition from Hardie's Casino, as well as Collins and Pancoast's Miami Beach Casino, the prospect of attracting more business was certainly an enticing reason to take a chance on Weiss and his culinary talent. It was, unquestionably, one of the best business moves Avery Smith ever made.

Joe and Jennie were both Hungarian born. Living in New York, where son Jesse was born in 1907, Joe was a waiter and Jennie cooked in small restaurants. Joe, Jesse recalled, had asthma, which bothered him greatly while on the west side of Biscayne Bay but seemed not to affect him while on the Ocean Beach side. Jesse was six when the family arrived, and they were true Miami Beach pioneers, the family being an integral part of Miami Beach's history since their arrival.

In 1918, for whatever reason (I have surmised the possibility of a disagreement between Weiss and Smith over Weiss's asking to become a partner in the Casino operation), Joe left Smith's Casino, and he and Jennie purchased a bungalow on Biscayne Street, just down the block from the Casino. They moved into the back of the small building, set up seven or eight tables on the front porch, cooked in the kitchen and called it "Joe's Restaurant" with "Shore Dinners a Specialty." Joe cooked, Jennie waited on tables and the legend of Joe's Stone Crab Restaurant began. "The food was great," Jesse recalled, "and when it got busy we started serving in our dining room."

The original restaurant opened daily for all three meals, primarily because it was the only restaurant on the beach side. For about eight years, there was no competition and people poured in. More than ninety years later, although there is now intense competition, people are still pouring in.

But how and when did the "stone crab" part begin? The origin of the use of stone crabs as a menu item dates back to 1921, when Carl Fisher's partner, James A. Allison, opened his Miami Aquarium at Fifth Street and the bay. Allison invited a Harvard ichthyologist down to do research, and he brought the crustacean to Joe, who told him that nobody would eat them. But after boiling them, serving them with hash-browned potatoes, coleslaw and mayonnaise for seventy-five cents for four or five

crabs and twenty-five cents each for potatoes or coleslaw, they became the restaurant's staple dish.

Joe's became—and remains, no matter how many short-lived chichi clubs or restaurants arise and last from Sunday till Monday—Greater Miami's real and true "in spot." From famous names of the past (Al Capone, Joe Kennedy, Amelia Earhart, the Duke and Duchess of Windsor, J. Edgar Hoover, Will Rogers, Ida and Isidor Cohen and Louis Pallot, among others) to noted individuals of today (including innumerable local mayors, commissioners, legislators, U.S. senators and industrial magnates), dining at Joe's or picking up at Joe's Take-Away still gives one the opportunity to see and be seen while enjoying one of America's greatest restaurants.

The complete Joe's story would take a book to tell—as it already has! But the story herein can not be complete without noting that Jesse and Grace's daughter, JoAnn, would eventually take the helm. Jesse Weiss was one of Greater Miami's most incredible characters, as well as a superb entrepreneur, and now, being told for the first time, he was one of my great mentors in the food and beverage business. Lunching with Jesse several times a week while I was managing the Piccadilly Hearth on Decorator's Row in Miami in the 1970s was like being tutored by one of the greatest restaurateurs of them all, and JoAnn learned the business from one incredible man.

While JoAnn's daughter, Jody, would spend some time working in the restaurant, son Stephen would attain the pinnacle of hospitality education, graduating (as did I) from Cornell University's famed School of Hotel Administration. Returning to Miami Beach, Steve tripled the size of the restaurant, added the parking garage and the take-away and ensured that, come what may, Joe's will remain preeminent in the restaurant business for at least another century.

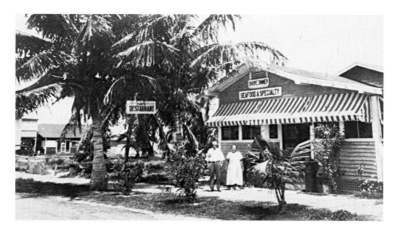

Where it all began. Joe and Jennie Weiss stand outside their already successful restaurant, circa 1921. Joe began cooking at Smith's Casino in 1913; the restaurant opened in 1918.

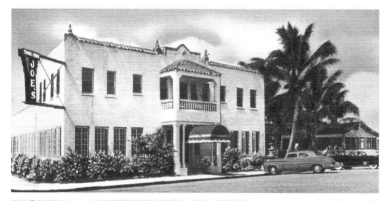

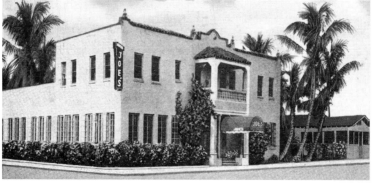

Although these two views of the restaurant with the entrance on Biscayne Street appear quite similar, there are distinct differences. The top image is earlier: note the sign extending from the corner of the building, the smaller palm trees and the fact that the bushes are lower than in the next photo.

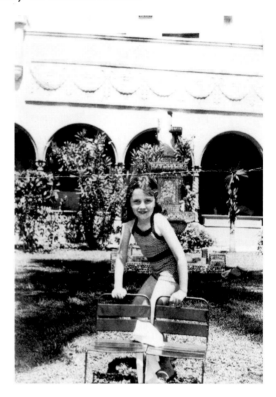

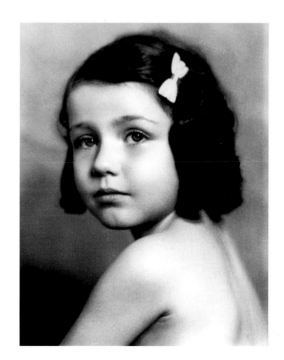

This page: JoAnn Weiss Bass as a child. A beautiful little girl, she remains today a vivacious, charming and gracious woman. *Courtesy City of Miami Beach*.

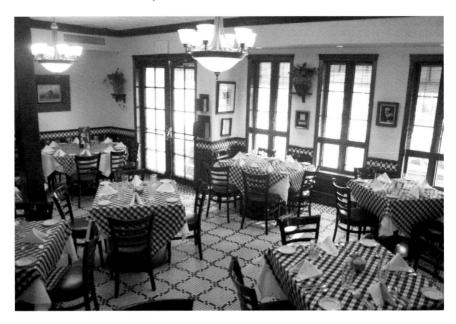

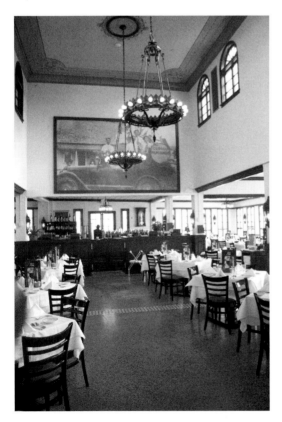

This page: Two views of Joe's interior show Jesse's corner and the center aisle of the restaurant. *Courtesy Joe's Stone Crab Restaurant.*

The Story of Miami Beach

Cocktails			Salads		
	Tomato Juice	.35		Cottage Cheese and Fruit	.50
	Stone Crab	1.25		Chef's Salad	.50
	Fresh Shrimp	1.00		Hearts of Lettuce	.40
	Florida Lobster	.90		Cole Slaw and Mayonnaise	.40
	Oysters	.75		Stone Crab	3.50
	Fresh Fruit	.60		Florida Lobster	1.75
				Fresh Shrimp	2.00
				Sliced Combination	.75
Relishes				Sliced Tomatoes and Spanish Onion	.60
	Celery and Olives	.75		Sliced Cucumbers and Spanish Onion	.60
	Mixed Pickles	.35		Lettuce and Tomatoes	.60
	Sweet Pickles	.35		Fresh Fruit	2.00
	Dill Pickles	.35		Sliced Tomatoes	.40
	Celery	.40			
	Queen Olives	.40	Sauces and Dressings		
	Stuffed Celery	.75		Garlic Sauce	.25
				Thousand Island	.25
Soups				Russian	.25
	Clam Chowder	.50		Roquefort	.40
				Hollandaise	.50
Fresh Seafoods (In Season)			Vegetables		
	Pompano, Garlic Sauce	3.00		Garden Spinach	.35
	Pompano	2.75		String Beans	.35
	Stone Crabs	3.25		Green Peas	.35
	Fried Shrimp, Tartar Sauce	2.00		Baby Lima Beans	.35
	Shrimp Creole	2.00		Broccoli	.50
	Fried Oysters	1.75		Green Asparagus	.75
	Salt Water Trout	1.50		Smothered Onions	.35
	Frog Legs	2.75		French Fried Onions	.60
	Florida Lobster	1.75		French Fried Eggplant	.50
	Spanish Mackerel	1.50		Grilled Tomatoes	.60
	Kingfish	1.50			
	Broiled Snapper	2.00	Omelettes		
	Scallops	2.25		Fresh Shrimp Omelette	2.00
	Scallops—Sauted	2.50			
Steaks-Chops Chicken			Desserts		
	Single T-Bone Steak	3.75		Home Made Apple Pie	.40
	Steak for two	7.50		Honey Dew and Strawberries in Season	
	Single Tenderloin Steak	3.50		Ice Cream	.40
	Broiled Lamb Chops	2.75		Pie a la Mode	.60
	Veal Cutlet with Tomato Sauce	2.00		Parfaits	.60
	Half Spring Chicken, Broiled or Fried	1.75		Frozen Eclairs	.60
	Chopped Tenderloin	2.00		Strawberry Sundae	.60
	Liver and Onions or Bacon	2.25		Compote of Preserved Fruit	.60
Potatoes			Cheese Saltines		
	French Fried	.40		Roquefort	.40
	Home Fried	.40		Camembert	.40
	Lyonnaise	.50			
	New Boiled Potatoes	.25	Coffee-Tea Beverages		
	Fried Sweets	.50		Coffee (Pot)	.25
	Hashed Brown	.35		Tea (Pot)	.25
	Julienne	.35		Iced Tea	.25
	Cottage Fried	.50		Iced Coffee	.25
	Mashed Potatoes	.25			
	Baked Potatoes	.35			

All Food Cooked to Order. Please Allow Time for Proper Preparation.

Please order with care. Each item is prepared to your individual order, therefore no substitutions or exchanges can be made.

CHOICE OF WINES, LIQUORS AND BEERS

50 Cents Service Charge
For Children

50 Cents Service Charge
when two persons share one order

Family-owned from day one, Joe's is now superbly managed by Miami Beach High and Cornell School of Hotel Administration graduate Stephen Sawitz. While everything at Joe's is nothing short of superb, it is worth noting—without fear of contradiction—that the hash-browned potatoes, the coleslaw, the mustard sauce and the key lime pie are the best in America, and in Florida, the words "Eat at Joe's" mean only one thing: dining at one of America's greatest restaurants. This 1963–64 season menu shows stone crabs costing $3.25 per order, and at that, they're not the highest-priced item on the menu. Key lime pie, today's *de rigueur* dessert, was not even on the menu then, while apple pie and sundaes were sixty cents. While prices have changed, the food, service and quality level at Joe's haven't. They are, simply put, the best there is.

They are beyond "good enough to eat," and when the server puts the stone crab claws on the table, with all the goodies and accoutrements, you know you are in dining heaven. But the best part about Joe's is a menu that offers everything from fried chicken and great salads to fish and steaks, all affordably priced. And that, with a warm welcome from "Bones," terrific service, great company and some local celebrity watching, is truly, when it comes to fine dining, as good as it can or will ever be. *Courtesy Joe's Stone Crab Restaurant.*

LINCOLN ROAD AND
WASHINGTON AVENUE

The credibility of any publication is strained when material in that publication is completely devoid of facts. It is even worse when that misinformation appears in a widely read official city-published publication. The article in question was on the Lincoln Road Mall's fiftieth anniversary, and in addition to other errors, the following comment appeared: "1912/Carl Fisher leads campaign to build the 'Saks Fifth Avenue of the South' on what he would name Lincoln Road after his idol, Abraham Lincoln." And worse, the "Saks Fifth Avenue of the South" comment is later repeated under the date of "1957." Sadly, in this article, there appeared to be no great concern for facts.

So let's set it—and get it—all straight: Fisher built Lincoln Road, which was the first street cut through the mangroves from ocean to bay, and he didn't lead a campaign to do so. He didn't have to; he was the builder of Miami Beach and didn't need to "campaign" for anything. Although Lincoln Road did not receive the appellation "the Fifth Avenue of the South" until the early 1930s and was never, ever, ever called "the Saks Fifth Avenue of the South," the truth and fact of the matter, according to Jane Fisher, is that Carl argued with John Levi over the width of the street as they began construction through the mangroves. Finally, in frustration, he told Levi, in no uncertain terms, that "Lincoln Road is going to be the American Rue de la Paix."

Apparently, it was overlooked in the aforementioned article that Saks Fifth Avenue is the name of a New York–based store that opened a branch on Lincoln Road. Saks moved to Bal Harbour Shops in 1976, the last name anchor to leave the street, and Saks Fifth Avenue is not and never was the nom de plume of the street.

Unhappily, there is yet another comment made in that article under the heading "1950s," which states that "Lincoln Road enjoys an all-time

high attracting premier retailers and big automobile names." This is incorrect. The automobile dealerships, including Packard and Cadillac, were long gone by the 1950s, the last of them probably departing by mid–World War II. It may have looked good in print, but it is completely without veracity.

Here, then, is how Lincoln Road and Washington Avenue came to be. For those not familiar with the city's geography, Miami Beach narrows at its south end and widens as it goes farther north. Fisher and Allison, in the pre-city's formative years, were not concerned about a Miami Beach that would continue to grow in a distant future but about building a city within parameters that would include two primarily commercial streets, which Fisher named "Lincoln Road" and "Washington Avenue." Although Fisher had great regard for the two presidents, it should be noted that the two streets, like Alton Road, were named after streets of the same names in Indianapolis. Without concern for or even thinking about a catchy title for the street, Fisher began the construction of Lincoln Road, starting with the removal of the mangroves in 1912, and numerous photographs attest to both the start and continuation of construction.

Fisher began the gentrification of the fifty-two-hundred-feet-from-ocean-to-bay street by building an indoor tennis court at the corner of James Avenue, one block west of Collins Avenue. James, when built, was dedicated by famed poet James Whitcomb Riley and had a large, landscaped median. Fisher then built the Lincoln Hotel on the southwest corner of Washington and Lincoln. Eventually, as Lincoln extended farther west, he built his office building (now the site of the Van Dyke Café) at 1000 Lincoln Road, on the south side of the street. Fisher also gave the city the property "up to the north side of Lincoln Road" for use as a golf course, but that restriction was only in force until 1939, when the covenant expired and the north side of Lincoln was opened to commercial development. (The Jackie Gleason Theater, formerly Miami Beach Auditorium; city hall; the parking lots behind city hall; and the site of the new Performing Arts Center were all part of the golf course, as was Miami Beach High. The only remnant of that course is the Par Three on Prairie Avenue behind the high school.)

Photographs and postcards in my collection show the Lincoln Hotel in place, with the golf course directly across the street, as early as 1923. As the city moved north, Lincoln Road became the site of the city's first church, Miami Beach Community, as well as its shopping hub. Longtime Lincoln Road aficionados recall, with great fondness, stores with names such as Nessa Gaulois, Exotic Gardens, Louis Restaurant, Adrian Thal Furs,

The Story of Miami Beach

David Alan, Moseley's, Lillie Rubin, The Slack Bar, The Dome (antiques), Enfield's Camera, Bonwit Teller, Saks Fifth Avenue, Burdine's, Henry Steig, Pappagallo and many others.

In 1957, with business declining as malls and hotels with retail shops began to open, Miami Beach businessman Hal Hertz, who was president of the Lincoln Road Merchants Association at the time, campaigned to convert the street into a glamorous pedestrian mall. Designed by, and with, Morris Lapidus serving as architect, ground was broken for the mall in the fall of 1959, and according to a paper written by former city manager Morris Lipp in 1962, the new facility opened to the public in time for Thanksgiving 1960. While the mall was initially successful, the competition from enclosed malls, coupled with declining tourism, eventually spelled the end of the street as a glamorous gathering place. Fortunately for the street, as well as for Miami Beach, the art deco boom fueled a rebirth, and Lincoln Road "turn[ed] the corner," returning to prosperity. Today, however, the home of too many "big box" stores, its future may once again be in doubt.

Washington Avenue is another story. By 1920, with Miami Beach five years old, Washington Avenue was already a commercial street. However, its great business boom did not begin until the inauguration of streetcar service (real trolley cars, not buses using the name "trolley") on or about December 18, 1920, following which Washington Avenue would see the cars operate up the center of the street from Biscayne Street to Dade Boulevard. Giving in to pressure from General Motors and the automobile industry–related conspiracy, the street car company ended Miami to Miami Beach via County (later MacArthur) Causeway service on October 17, 1939.

While Morris Brothers Department Store; the Governor and Ambassador Cafeterias; the Famous, Royal Hungarian and Harfenist (as well as other) Restaurants; and the Cameo, Cinema and Variety Theaters would make Washington Avenue a wonderful street on which to shop, dine or enjoy a movie, hotels such as the Nash William Penn and the Blackstone were well known during the years from the 1930s through the '60s. Washington Storage (now the Wolfsonian-FIU Museum of the Decorative and Propaganda Arts), city hall, Kress, McCrory, Washington Federal Savings, Reisler Brothers Sporting Goods, Butterflake Bakery, Thrifty Supermarket and innumerable other establishments called Washington Avenue home, as did Miami Beach's first synagogue, Beth Jacob, at number 311.

Washington Avenue declined, as did Lincoln Road, in the late 1950s, becoming seedy and run-down and remaining so through the 1970s. It was one history person long overlooked in Miami Beach, Ray Redman (1905–1971), who, heading the Washington Avenue–South Shore Association for many years, would be responsible for the inauguration of the plans to rebuild south beach. Redman, in business on Miami Beach from 1935, was the formulator and driving force behind what eventually became, pre–Barbara Capitman and pre–art deco district, south beach redevelopment. It was Redman who, in those declining days of the two streets, initiated the use of the term "South Shore" at a time when "south beach" was almost as much an epithet as it was a location.

Driven by the art deco/SoBe boom, Washington Avenue has become a hot spot for young people, for great dining and for interesting, small-store shopping. To paraphrase the car commercial, "This isn't your grandma's street!"

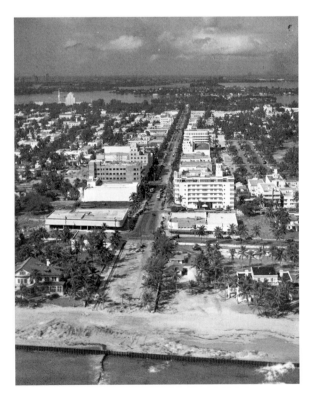

From the collection of Aristotle Ares comes this extremely rare view of Lincoln Road looking west from the Atlantic. The first street is Collins Avenue, with the building that would eventually house the Greyhound Bus station and the airline ticket offices under construction at left. The Albion Hotel at James Avenue is the seven-story building at right, and the office building that would eventually house Mary Jane Shoes is under construction on the left side of Lincoln at Washington Avenue. The Fisher-built Flamingo Hotel is in the distant left; the Flagler Monument on Monument Island, also built by Carl Fisher, is just behind and to the left of the Flamingo.

The Story of Miami Beach

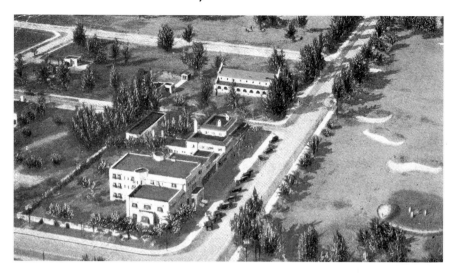

For Miami Beach historians, "it just doesn't get any better than this!" The Lincoln Hotel is on Lincoln at left. The Community Church is also on the left, just past the hotel, on the block between Drexel and Pennsylvania Avenues. The municipal golf course is clearly shown at right. This is truly an image to be cherished.

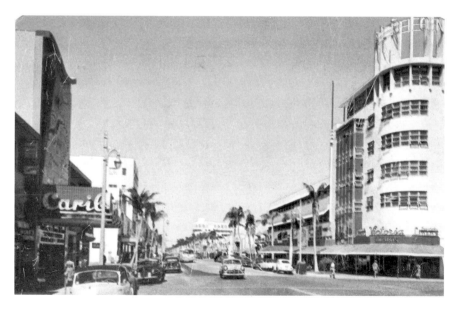

The beautiful Carib Theater is on the left and the Albion, at James and Lincoln, is on the right. A Mercury cab is eastbound, with a Miami Beach Railway Company Twin Coach bus behind it. This photo is circa 1949.

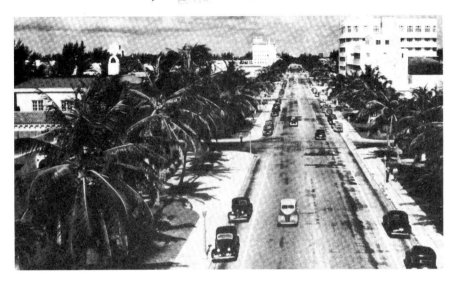

Circa 1937, this image looks west, with the Sterling Building on the right (north) side of Lincoln and the Fisher Building on the south side of the street.

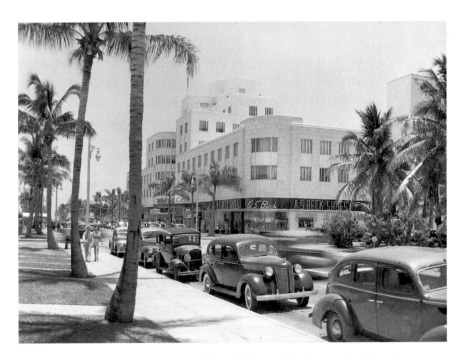

Another wonderful Lincoln Road shot! Taken in front of the Community Church, we are looking east toward Drexel Avenue, A.S. Beck Shoes and the Mercantile Bank Building, with the Beach Theater marquee visible behind the third coconut palm. *Photo by G.W. Romer, circa 1938.*

The Story of Miami Beach

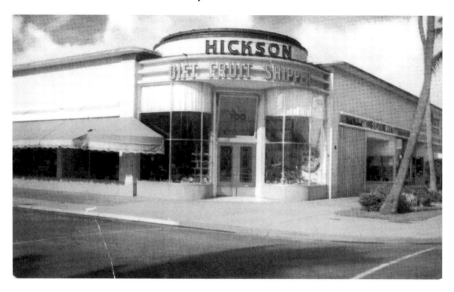

Hickson, 700 Lincoln Road, on the southwest corner at Euclid Avenue, advertised itself as "Florida's oldest fruit shipper."

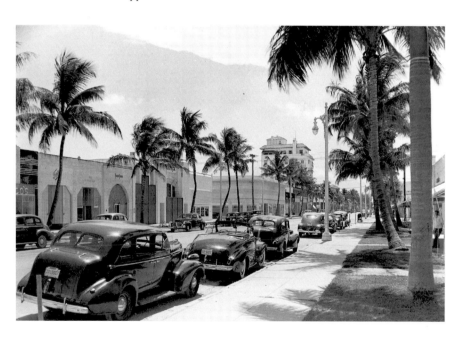

Looking west toward the Fisher Building at 1000 Lincoln Road, late 1930s. *Photo by G.W. Romer.*

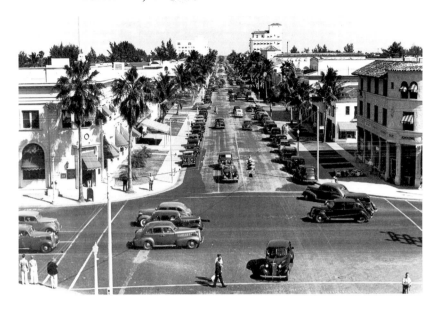

For whatever reason, the farther west one goes on Lincoln Road, the fewer the views, hence this superb photograph, taken in the very late 1930s, is a true "period piece." Looking east from Alton Road, Miami Beach First National Bank is at left and Dade Awning at right. Neither building exists today. The Colony Theater, one block east, is featuring Frederic March (the sign visible on the right), and the Fisher Building (far right) and Sterling Building (far left) are also clearly visible.

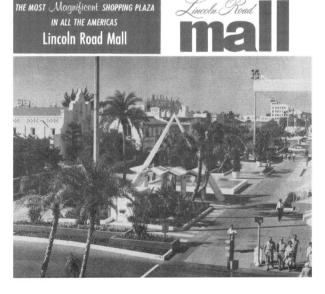

Somewhere, somehow, there must be more of these, but upon publication of this book, this is one of the few known extant brochures ballyhooing the opening of Lincoln Road Mall. Likely issued for the mall's opening in 1960, the only automobile visible is a 1959 or '60 Oldsmobile. Nowhere in this brochure is an issuer or producer named, but it was, quite likely, published by the Lincoln Road Mall Merchant's Association, headed by Hal Hertz. The businesses are named in the brochure by category and address.

The Story of Miami Beach

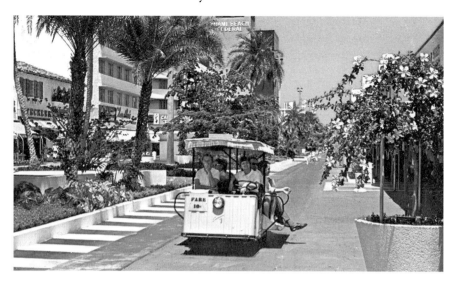

Several years after the mall opened, electrically powered trams carried shoppers the length of the former automobile thoroughfare. Although the fare was a modest ten cents, the trams only lasted for a short time. This view looks east from between Pennsylvania and Drexel. The Lincoln Theater is on the left; the featured movie is *Pepe*, starring Cantinflas.

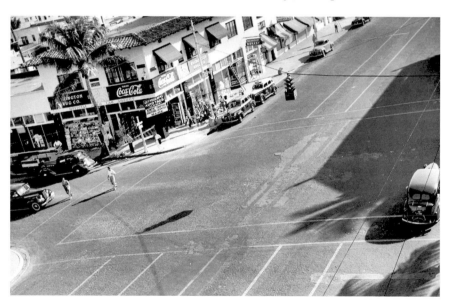

The streetcar tracks are, sadly, gone in this December 1940 photo. When Fifth Street was widened in the 1970s, the wonderful building we are looking at on the southeast corner of Fifth and Washington, as well as everything on the south side of the street from Alton to Ocean, was removed in order to broaden that thoroughfare. And what are we looking at? A great memory for longtime Miami Beach residents: Washington Drugs and Miami Beach Auto Tag Agency on the ground floor, the offices of the revered Hyman Galbut on the second floor and Paramount Bakery on the Washington Avenue side two doors south of the drugstore.

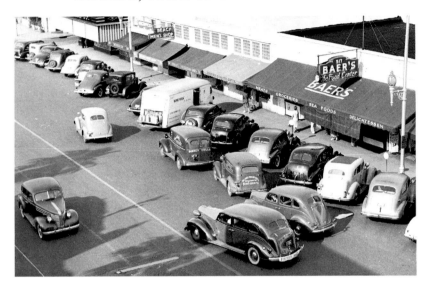

Another December 1940 photo features Baer's Food Center at 517 Washington Avenue on the east side of the street. Rogers Quality Gifts is next door, with a cancellation shoe store and Beach Men's Shop farther down the block. The clock on the Baer's sign facing the street tells us that it is 12:10 p.m., and Williams Poultry and Egg, a bakery and Home Milk are making their deliveries.

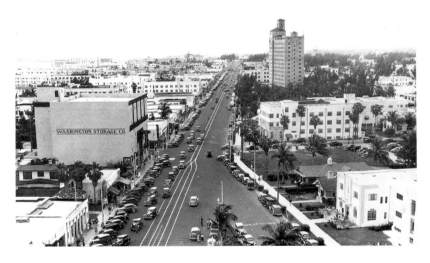

The streetcar-passing track on Washington was in front of Washington Storage (at left in this view looking south between Eleventh and Tenth Streets), with the Blackstone Hotel in the distance on the right. Note the two small homes on the right next to the two-story apartment house, one the famed coral rock house at number 1030 that belonged to Normandy Isle and Surfside developer Henri Levy. The empty lot on the right at the corner of Tenth Street is now a city parking lot, and the former Washington Storage building, with a floor added, is now the Wolfsonian-FIU Museum of the Decorative and Propaganda Arts.

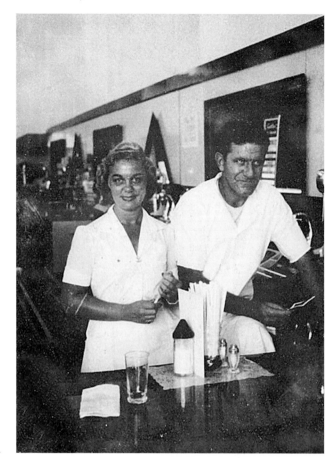

This page: While Bill Rabinowitz and one of his waitresses greet customers, Bill's brother, Milton "Tiny" Rabinowitz, helps the driver of the Home Linen Supply truck get close enough to the store (Bern's, on the southeast corner of Ninth Street and Washington) to complete his delivery. Both photos were taken following the 1947 hurricane ("the big one" has hit Miami several times). *Courtesy Ann Rabinowitz*.

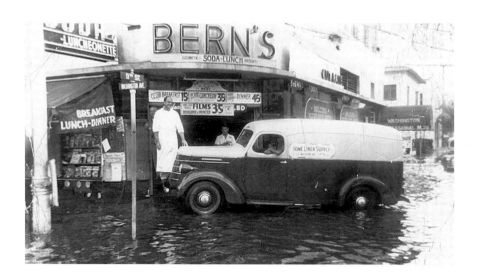

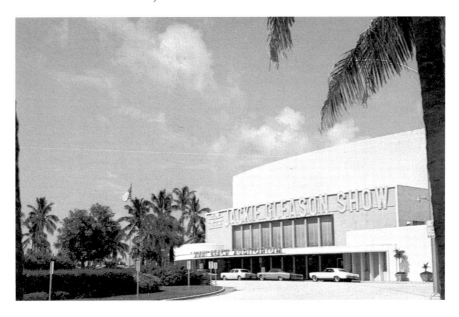

C O P Y

WASHINGTON AVENUE - SOUTH SHORE ASSOCIATION, INC.
1370 WASHINGTON AVENUE • MIAMI BEACH, FLORIDA • TEL. 534-4797

January 14, 1965

The Honorable Haydon Burns
Governor of Florida
State Capitol
Tallahassee, Florida

Dear Governor:

On behalf of the officers and members of the Washington Avenue - South Shore Association we wish to again congratulate you and pledge you our fullest cooperation and support, and are confident that you will be a great governor for all of Florida.

When you first appeared in Miami Beach at the Carillon Hotel I addressed you as Governor also at the Ribs & Roast, and last Saturday night at your Inaugural Ball it was my great pleasure to greet you as the Governor of Florida - and have been for you all the way.

You may recall I spoke to you about our No. 1. Project for many years now in our program of redevelopment, beautification and promotion to attract people to the South Shore area of Miami Beach, the construction of a "SOUTH SHORE PARKWAY", a wide, landscaped parkway, continuation of the East-West Expressway at the east end of MacArthur Causeway to the ocean on Fifth Street, Miami Beach, which is Highway 41 and A1A, and leads directly to one of Florida's most beautiful park beaches, Lummus Park.

The Washington Avenue - South Shore Association, a property owners' organization and its hotel and merchants' divisions, represents approximately 200 property owners, 7 financial institutions, 200 hotel owners and 400 merchants in the South Shore area of Miami Beach which has an assessed value of over 250 million dollars. This area is located south of Dade Boulevard to Government Cut, from the ocean to the bay.

We are enclosing a booklet which will give you some background information on this project and are placing our hopes in you to include the "SOUTH SHORE PARKWAY" in the East-West Expressway.

With all good wishes,

Respectfully yours,

Ray Redman, Executive Vice President
WASHINGTON AVENUE - SOUTH SHORE ASSOCIATION

RR:ir

A PROPERTY OWNERS' NON-PROFIT ORGANIZATION, CHARTERED IN 1959, FOR THE WELFARE, BEAUTIFICATION AND PROMOTION OF WASHINGTON AVENUE AND THE SOUTH SHORE AREA.

OFFICERS

PRESIDENT
NATHAN S. GUMENICK

EXECUTIVE VICE-PRESIDENT
RAY REDMAN

VICE-PRESIDENTS
S. J. HALPERIN
MAX BODERMAN
CARL T. HOFFMAN
JOSEPH M. ROSE
JAKE STEIN
NEWTON H. BOLLINGER

TREASURER
MARCUS O. SAROKIN

SECRETARY
HON. HYMAN P. GALBUT

BOARD OF GOVERNORS
MAX BODERMAN
MORRIS H. BROAD
SOPHIA BRONSTON
WM. BURBRIDGE
BARON DE HIRSCH MEYER
NEWTON H. BOLLINGER
C. D. BLACKWELL
CHARLES L. CLEMENTS, JR.
LEO A. CHAIKIN
G. L. DEVINE
DAVID DIAMOND
MICHAEL FORTE
ARTHUR FEIGELES
WM. FLAXHOLTZ
NATHAN S. GUMENICK
JACK D. GORDON
HON. HYMAN P. GALBUT
NORMAN GREENE
S. J. HALPERIN
CARL T. HOFFMAN
HON. CHARLES F. HALL
GEORGE W. HIRSCH
BY HOWARD
WILLIAM H. JOHNSTON
MORRIS LERNER
A. L. MAILMAN
WM. G. MECHANIC
CHARLES MOUYOS
ALBERT NASH
HON. D. LEE POWELL
CLAUDE A. RENSHAW
JOSEPH M. ROSE
LEO RADOFF
RAY REDMAN
MARCUS O. SAROKIN
PHILIP SIMON
JACK SILVERMAN
FRANK SMATHERS, JR.
MILTON SMITH
MARTIN A. SMITH
JACK STEIN
MICHAEL SOSSIN
HARRY SCHACK
DANIEL TARDASH
JOSEPH WEINTRAUB
MILTON WEISS
SIGMUND WEINTRAUB
WALTER WAXMAN
BY YAEGER

LEGAL COUNSEL
MARTIN A. SMITH

PUBLIC RELATIONS
RAY REDMAN AND ASSOCIATES

AUDITORS
HIRSCH, KOHN & DORFMAN, C.P.A.

HOTEL DIVISION
SOUTH SHORE HOTEL ASSOCIATION

MERCHANTS' DIVISION
WASHINGTON AVENUE
SOUTH SHORE
MERCHANTS' ASSOCIATION

Above: Originally opened as Miami Beach Auditorium, the building became the home of the Jackie Gleason Show in the late 1960s. Later enlarged, it is now the twenty-seven-hundred-seat Fillmore Miami Beach at the Jackie Gleason Theater, still located just north of Seventeenth Street on Washington.

Left: Longtime Miami Beach resident and businessman Ray Redman was executive vice president of the Washington Avenue–South Shore Association, a group working for the redevelopment of south beach well before an overbearing, loudmouthed blusterer and a clergyman purloined the idea for their own benefit. This 1965 letter to then Florida governor Haydon Burns explains who the group is and what its goal for south beach/south shore was. *Courtesy the Redman family.*

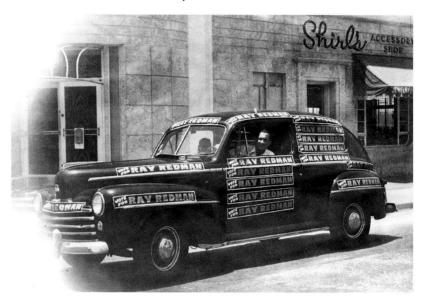

Ray Redman ran unsuccessfully for Miami Beach Council in 1951 and is shown on Washington Avenue in his campaign car in this Ken Laurence photograph from June 5, 1951. *Courtesy the Redman family.*

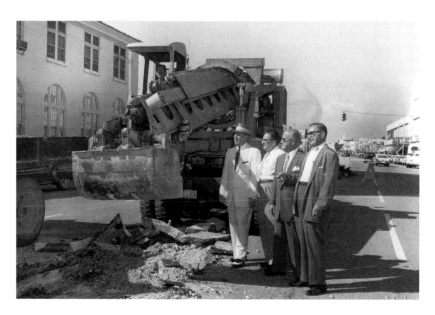

Ray Redman is at far right as the bulldozer begins the work of tearing up Washington Avenue to prepare for the installation of upgraded medians, a project championed by the Washington Avenue–South Shore Association. (Unfortunately, only the last names of the other three—from left, Smith, Potter and Sarokin—are on the back of the photo.) *Courtesy the Redman family.*

OCEAN DRIVE
AND COLLINS AVENUE

J.N. Lummus (Lum-miss, NOT Loom-miss) was the first mayor of Miami Beach and probably writes more of and about Ocean Drive in his *The Miracle of Miami Beach* than any other person, while Nash, in his *The Magic of Miami Beach*, carefully tells the story of the four casinos that were built on the ocean, from south to north: Smith's, Hardie's, Cook's and Fisher's (also called the St. John Casino). All were bathing, not gaming, casinos, and all were constructed so that, once the street had been laid out, they would be perfectly positioned for the business that would come across the Collins Bridge following its opening. (Remember that, prior to the bridge opening in 1913, people took the ferries from the Miami side to the long pier at the foot of what would become Biscayne Street, the most southerly street on Miami Beach, and walked across the island to their casino of choice.)

Although Jerry Fisher writes in detail of the Collins Bridge and Collins Canal in his book *The Pacesetter*, a biography of his distant relative Carl Fisher, neither he nor Helen Muir in *Miami, USA*, or any of the other Miami Beach writers, detail the naming of Collins Avenue, hence we can only assume that the name sounded good to Collins and Pancoast and was accepted by Fisher as legitimate. Ocean Drive, however, is another story.

On July 9, 1912, the Lummus brothers, through their Ocean Beach Realty Company, filed the first plat for a subdivision on what would become Miami Beach two years and nine months later. On November 5, 1915, several months after Miami Beach's incorporation as a town, the Ocean Beach Realty Company sold to the town a strip of beachfront extending from Sixth Street to Fourteenth Place. The frontage of 4,120 feet from end to end and from the ocean to the street was purchased by the town for $10 per front foot, at an agreed upon price of $40,000, that amount payable over twenty years at 5 percent interest per year on the balance.

The Story of Miami Beach

Most importantly, and unlike the golf course north of Lincoln Road, the oceanfront park (to be named Lummus Park) was to be maintained as a public park by the town (later city) in perpetuity, with no wiggle room for the kind of dastardly and corrupt actions that a city council in the 1970s had no problem involving itself in as it gave away city-owned land on Biscayne Bay south of Fifth Street and on the south side of Biscayne Street adjacent to Government Cut. Every member of that council who voted to approve that action should still be in jail today.

Lummus opened his office in the Lummus Building on the corner of Ocean Drive and Biscayne Street, and it was in that building that all meetings of the Miami Beach Council were held during his tenure of mayor, making that building Miami Beach's first town hall.

In 1915, the first hotel on Miami Beach, Brown's, was opened, and for the first time beachgoers had a place to stay overnight. Nash (quoting C.W. "Pete" Chase in the former's *The Magic of Miami Beach*) notes:

> *Brown's Hotel was a wooden building of the old school built at First Street and Ocean Drive even before the time of Hardie's Casino. The streets near here were paved then, but the sidewalks consisted only of wooden planks laid on the ground.*

The first oceanfront hotel on Miami Beach was built by Ora Wofford, who named it The Wofford. The name "Wofford Beach Hotel" would not appear until some years later, even though Jane Fisher, in *Fabulous Hoosier*, refers to the latter name as the original name, which it was not. After Wofford's and his son John B.'s deaths, the hotel was operated for many years by John's widow, Olive, and it is possible that she added the word "Beach" to the name. Just north of where the Roney Plaza would be built, the Wofford stood at Twenty-fourth Street and Collins Avenue, directly opposite Lake Pancoast. The oceanfront promenade, directly behind the hotel, started at the south end of the Wofford and extended north for two blocks, the location of innumerable photographs and movie scenes. While the list of hotels built on Ocean Drive and Collins Avenue would be far too lengthy for recitation herein, several other items regarding the two streets might be of interest to readers.

Arthur Pancoast, Thomas's son, was employed by Fisher, first building the golf course and then managing the Fisher (St. John) Casino for eight years. As Miami Beach grew, attracting more and more wealthy northerners, Arthur recognized the need for another truly elegant hotel on the oceanfront. Since his own home occupied what he believed to be an ideal spot, even though

it was somewhat farther north than development had reached, he moved his residence from the oceanfront knoll at Twenty-ninth and Collins to a frontage on Indian Creek north of his father's house, following which he built the Pancoast Hotel, which, for many years, even with the opening of the larger and more glamorous Roney Plaza, remained one of the beach's outstanding landmarks and hostelries. In the late 1950s, the Pancoast was torn down and the extant Seville Hotel was built in its place. Fortunately, the circular driveway in front of the Seville still exists to remind visitors of the spot upon which Fisher loved to pose his elephants during the heyday of the 1920s.

Both streets would eventually be overbuilt with hotels, but at least, and thanks to the foresight of the Lummus brothers and the original town fathers, all of the hotels on Ocean Drive from Sixth Street to Fourteenth Terrace were built on the west side of the street, leaving the oceanfront free of commercial buildings. That lesson, unhappily for Miami Beach and its residents, was not learned or remembered.

The later overbuilding, the taking away from the public of its view of the ocean and, most importantly, the rape of Collins Avenue north of the Eden Roc when one of the most magnificent residential streets on earth was rezoned for high-rises were architectural crimes of immense significance, if not stupidity. Thanks to the avarice and indifference to the wishes and desires of the people of Miami Beach, who two years earlier voted against rezoning Collins Avenue, the 1960 city council voted three to two to allow the homes north of Forty-sixth Street to be razed and mostly architecturally undistinguished, poorly sited, shoulder-to-shoulder apartment houses (today almost all condominiums) to be built in their place. Collins Avenue, from the Forty-sixth Street Beach to the Bath Club, is nothing other than Park Avenue south, with buildings on either side of the street blocking both the sunlight and the view. That vile decision by that council was an event that was, along with the vote to allow the taking and selling of public land to developers on Alton Road south of Fifth Street and on the south side of Biscayne Street, one of the most shameful decisions that any municipal government in America has ever made.

The Story of Miami Beach

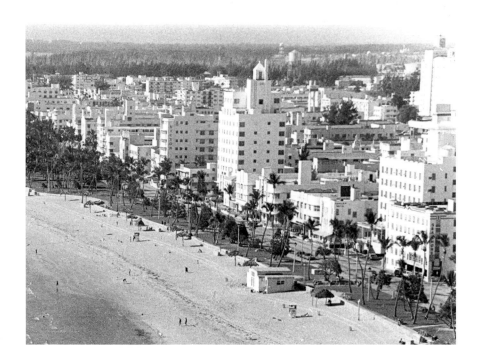

Above: What all of Miami Beach and its neighboring communities' beachfronts could have and should have looked like. Lummus Park in all its glory, shown here on March 24, 1976, in a Robert Berman photograph, cost the town $40,000 in 1915.

Right: What existed on most of the rest of the Miami Beach beachfront prior to the beach restoration project funded by the federal government, the state and cities was this: looking north from above the Carillon Hotel at Sixty-seventh Street and Collins, October 5, 1970.

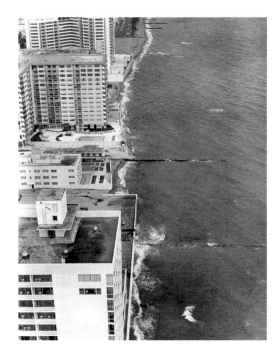

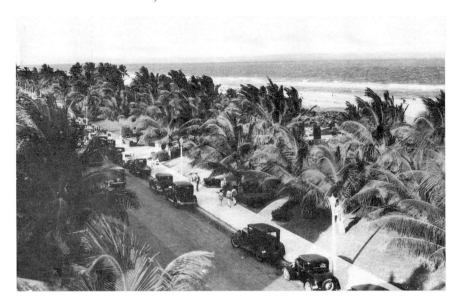

The lushness of the planting of coconut palms on the grassy area between Ocean Drive and the beach makes the idea and concept of Lummus Park even more attractive and alluring. Photo circa 1924.

At Tenth Street and Ocean Drive, the city erected a formal entrance to the park. This R.E. Simpson photograph is circa 1940, and the entranceway has long been replaced by the Tenth Street Auditorium and Beach Patrol Headquarters.

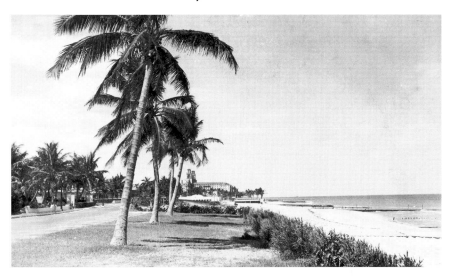

Another Simpson photo, taken circa 1930, looks north from approximately Twelfth or Thirteenth Street, the only building visible in the view being the 1925-built Roney Plaza Hotel in the distance.

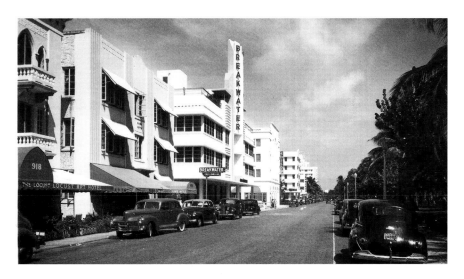

Ocean Drive, thanks to the late Barbara Capitman, looks much the same today as it did in this 1944 photograph taken in front of number 918, the Locust Apartment Hotel. North from the Locust is the Park Apartments and, north of that, the Breakwater, Edison, Clevelander and Congress Hotels.

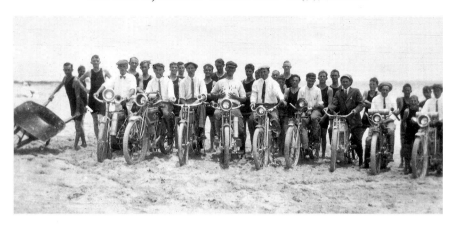

An extremely early and very rare photograph of the beachfront, this group of young motorcyclists posed on the sands of Ocean Beach sometime in the early teens, likely prior to Miami Beach's incorporation. A photo postcard from a private album, this is a one-of-a-kind image.

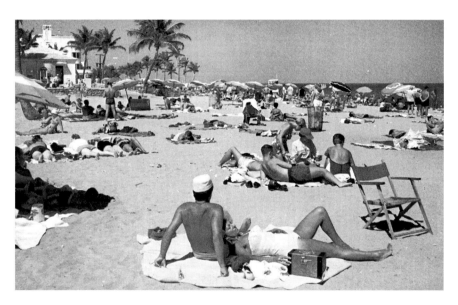

Although none of the beaches facing Ocean Drive or Collins Avenue are as lengthy as Lummus Park's magnificent stretch, the city has, through the years and mostly under terrible duress from its citizens, purchased short stretches of beach for public use. One of those, the Seventy-third Street Beach, shown here, is a block long, from Seventy-second to Seventy-third Streets, at which point Seventy-third Street goes east another block to Ocean Terrace, which runs two blocks north to Seventy-fifth Street and rejoins Collins a block west. The Seventy-third Street Beach and North Shore Park, a municipal facility on the west side of Collins Avenue that extends three blocks west to Dickens Avenue, exist as a result of a 1930s land swap with the U.S. Coast Guard that gave the Coast Guard the underwater land adjacent to the County (later MacArthur) Causeway on which Terminal Island and the Miami Beach Coast Guard base would be built.

Truly one of Miami Beach's most beloved modern-day characters, Robert Kraft, aka "Raven," began running eight miles a day, every single day of the year, on January 1, 1975. On March 29, 2009, with ESPN filming for a national audience, Raven completed his 100,000th mile at the Fifth Street Lifeguard Station. A true gentleman, he is an inspiration to athletes and fitness buffs worldwide.

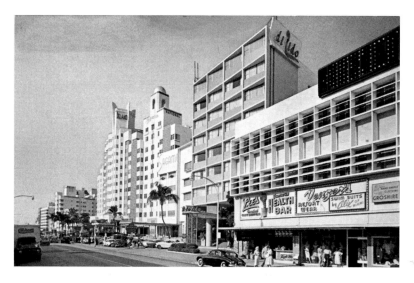

Looking north on Collins from just north of Lincoln Road, the shops in the building that housed Wolfie's Lincoln Road include Venzer's Resort Wear and Lee's Famous Health Bar, made all the more famous by the fact that "Chick" Chikofsky, later Dave Rogers, worked there for several years. Hotels visible in the photo include the Collins Avenue wing of the DiLido, the Sagamore, the National and the Delano.

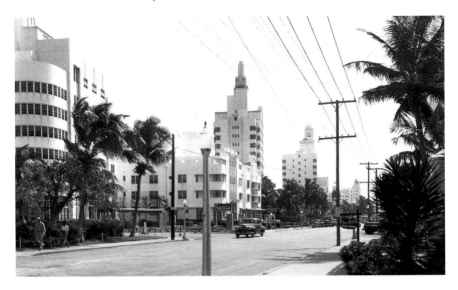

A World War II–era photo looks south from Eighteenth Street and shows the Raleigh, Richmond, Ritz Plaza and National Hotels; the Delano had not yet been built.

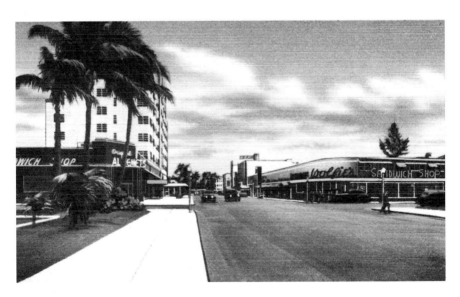

Looking south from Collins Park, between Twenty-second and Twenty-first Streets. Al Nemets Sandwich Shop, later the site of Angie and Fred's, is on the left (east) side and Wolfie's 21 is on the right. The hotel on the left is the Dempsey-Vanderbilt.

The Story of Miami Beach

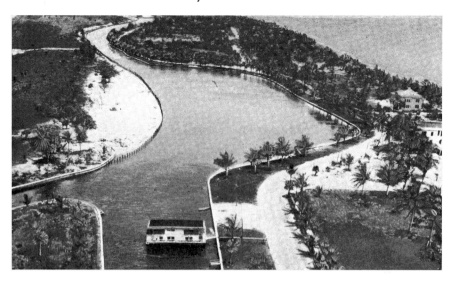

An aerial view taken above the block between Twenty-third and Twenty-fourth Streets. The Roney Plaza would, in about eight years, be built in the open area at right and the Wofford Hotel just north of that. Directly in front of the camera is Lake Pancoast, and the Collins Canal to Biscayne Bay is at left.

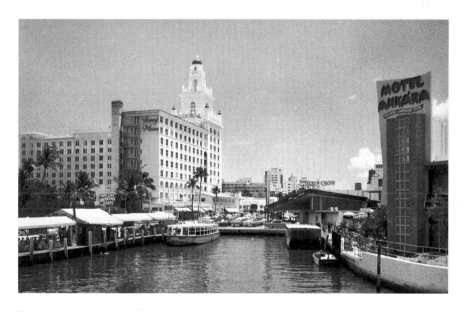

From ground level, Lake Pancoast, with one of the sightseeing boats docked there, is in the center. The Roney Plaza Hotel is at left and the Ankara Motel is at right. The Roney's south side fronted Twenty-third Street, which was, for many years, the heart of Miami Beach's tenderloin district.

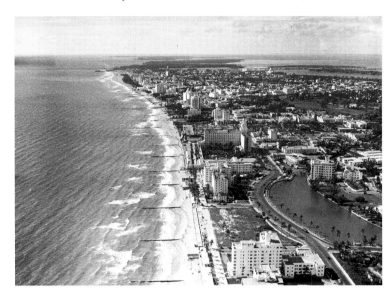

A circa 1956 photograph shows Collins Avenue at the north end of Lake Pancoast, Indian Creek Drive curving away from Collins at the bottom right. The Helen Mar Apartments are at the lower right of the Lake and the Roney Plaza is at left. The Wofford Beach Hotel fronts Collins at the lower end of the lake, and the sightseeing boats (seven of them) await their sightseers.

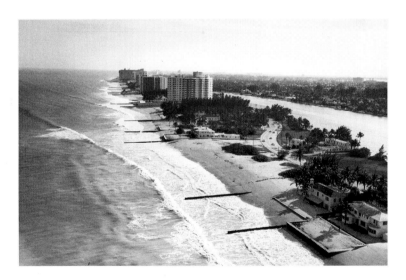

It was March 9, 1962, when Chris Hansen took this photograph, a moment in time hard to believe today. Only the first two of the monstrosities had been constructed north of the Doral, Collins was still four lanes and at least six of the beautiful private homes shown in this photo were extant. Raping one of America's most magnificent residential streets was an unforgivable act of corrupt greed by a city council driven only by its own self—and not the city's greater—interest.

The Story of Miami Beach

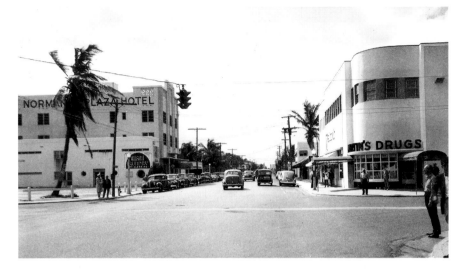

Collins Avenue and Seventy-first Street looking south, circa 1940. The Johnina Hotel would later be built on the southeast corner (across the street on the left). Miami Sundry is the two-story building on the left, while the Normandy Plaza Hotel, also on the left, engaged in the practice of discriminating against Jewish guests, advertising "Restricted Clientele." Martin's Drugs, a fixture in the north beach neighborhood for many years, anchors the southwest corner.

Miami Beach's first mayor, J.N. Lummus, was a friend and business associate of Carl Fisher. His foresight, vision and belief in the future of the city he helped found in 1915 have stood Miami Beach in good stead for almost a hundred years.

THE BATHING CASINOS

There were four great casinos on the oceanfront from Twenty-third Street south in Miami Beach, one smaller one in north beach and one in Sunny Isles, but it was only the Harvey Baker Graves–owned Sunny Isles Casino that offered both bathing and gaming. The Miami Beach casinos have, in other Miami Beach books, been noted only peripherally, when in reality, they were major and important gathering spots for food, fun and recreation.

It is my intent, for the first time, to properly memorialize the five casinos on Miami Beach, and, indeed, each had its supporters and enthusiastic "regulars." Once, it seems, that a person had developed loyalty to his or her favorite bathing and dining destination, he or she would not only, for the most part, patronize that one place, but, in addition, would participate in good-natured competitions—swimming, diving, beach and card games—against the other casinos.

What should be unequivocally understood by the reader is that Miami Beach's four casinos did not have or operate games of chance. They were strictly bathing casinos, although more was offered than just a natatorium for aquatic enjoyment or amusement. In the earliest years, one took the ferry to Ocean Beach or rode across Biscayne Bay on the Collins Bridge and, later, the County Causeway. Eventually, with the Collins Bridge replaced by the privately owned Venetian Causeway and trips to the Miami Beach side available by private boat, automobile or streetcar, business at the casinos boomed.

A person planning to spend a day or evening at one of the casinos would arrive as early as possible if going for daytime activities or in time for the evening entertainment if an event was scheduled for late in the day or after sundown. Arriving at the casino, the first stop was at the registration

counter, where a locker and a wool bathing suit could be rented. Each of the lower beach casinos had that establishment's name heavily embossed on the bathing suit, and even though there were apparently several thousand bathing suits available for rental, only one bathing suit, a size forty-six from Smith's Casino (name on the front and on the label attached to the rear inside of the suit, complete with the casino name and "Miami Beach, Fla." below that) is known to exist, having survived hurricanes, fires and demolition, now residing and reposing in The Bramson Archive.

Once the guest secured his or her locker and bathing suit, he or she would change from street clothes into bathing attire and avail him or herself of the activities offered, including dining facilities ranging from quick-snack-type lunch counters to full-service restaurants, where anything from a cup of coffee to a great meal could be ordered. The casinos also had card rooms and activities for children. Swimming and diving lessons were offered, while sundries and men's and women's beach attire were sold. In the case of the Fisher Casino, a wide range of stores was also available.

The first-built and most southerly of the casinos was Smith's Casino, owned by Avery Smith, at Biscayne Street and Ocean Drive. The next heading north was Hardie's, owned by county sheriff Dan Hardie, at approximately First Street. The third casino was Cook's, at the intersection of Fifth Street and Ocean Drive. Farthest north of the four original casinos was Collins and Pancoast's Miami Beach Bathing Pavilion and Swimming Pool (later the Miami Beach Casino), which was purchased by Fisher, who, spending $350,000, substantially enlarged it and named it the Casino St. John. Located on the block between Twenty-second and Twenty-third Streets, it would later be known as the Roman Pools and finally, prior to its closing, the Everglades Cabana Club.

The fifth Miami Beach casino was the last built and the smallest, as well as the longest lasting; it didn't close until sometime in the late 1950s. The Surfside Casino was located at Seventy-second Street and Collins and advertised itself as "the South's newest streamlined bathing pavilion featuring sunken sun patio, private dressing rooms, modern cabanas and private beach." There may have been a snack bar at the Surfside, but for those patrons who were hungry, the Seventy-first Street area had several restaurants, including a Pickin' Chicken, in proximity.

The original bathing house on what would become Miami Beach was a two-story building constructed at the southern end of the island in 1904 by a former Connecticut schooner captain, Richard M. Smith. In 1908, according to Jerry Fisher, Avery Smith leased the land and the bathhouse and, in 1909, with his friend James C. Warr, formed the Biscayne Bay

Navigation Company to develop a beach resort with suitable transportation to and from Ocean Beach. Smith rebuilt the facility with docks and piers on either side of the bay and added a boardwalk; the entire new destination was given the name "Fairy Land." (A photograph in my collection shows the pier on the west side of Ocean Beach with visitors leaving the boat and passing a sign that says "Entrance to Fairy Land.")

Unhappily for historians and researchers, little is said in any of the Miami Beach histories of the lives and times of the casinos, of their daily operations, of the people who frequented or managed them or of their demise. Hardie's Casino, like Smith's and Fisher's, was brutally damaged by the September 17 and 18, 1926 hurricane, which killed over four hundred Miamians and left sand piled to the third floor of the Roney Plaza. The casinos and their respective histories have received scant notice or coverage in the various books about Miami Beach, and even in the books and booklets published following the 1926 storm, the casinos are given short shrift, with, at most, two photographs of one of the ravaged buildings appearing therein.

Although not meant to be an exhaustive history of those highly visible, often-crowded and warmly remembered edifices, this chapter does, for the first time ever, bring forth the images and refresh the memories of the fans of those great and hallowed buildings.

Suffice it to say, the bathing casino era was an incredible moment in time, and one that we shall never see again. Smith's and Hardie's limped into the Depression, closing sometime before World War II. Cook's continued in business, although mostly as a beach clothing and accessories outlet, and the building lasted into the 1960s. The Everglades Cabana Club closed in the early 1950s and for many years survived as a sealed-up and hulking reminder of better days, finally succumbing to the wrecking ball and being replaced by the Twenty-second Street Holiday Inn. And finally, the Surfside Casino, at the south end of the Seventy-third Street Beach, faded into oblivion, ignominiously replaced by an out-of-place, out-of-context, completely wrong for the neighborhood and ugly (the kindest word that can be used here) high-rise apartment building. Sadly, time and the tides have, for the most part, been terribly unkind to Miami Beach's history.

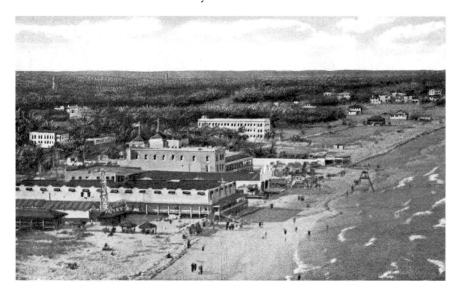

Smith's Casino (foreground), with Hardie's Casino, the four-story building immediately north of it.

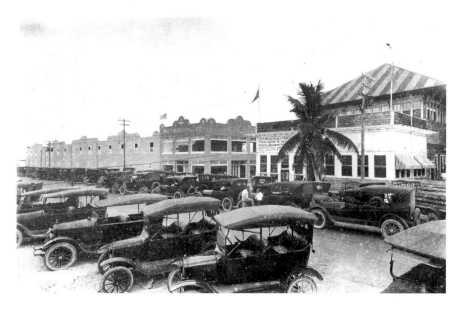

In this absolutely spectacular image, Smith's Casino is shown in 1921. Looking carefully at the sign on the front building to the left of the palm tree, one can see that the dining room's specialty was seafood and shore dinners, likely a holdover from Joe Weiss's five years there.

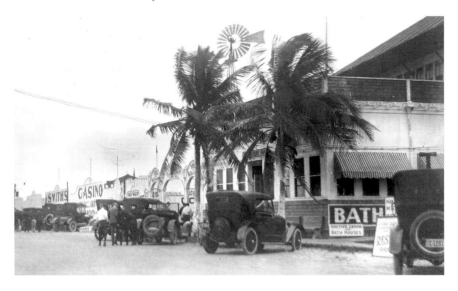

A similar, but earlier, view of Smith's, also from the north looking southeast.

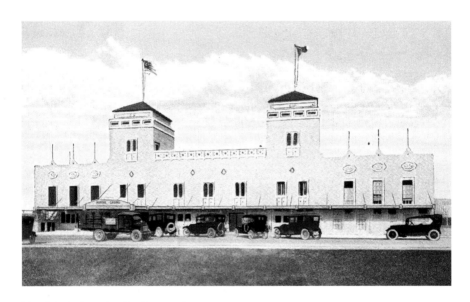

Hardie's Casino, shortly after opening.

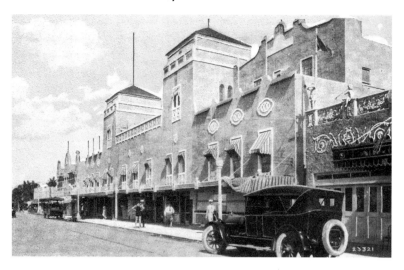

As the reader will note, the building has been enhanced with the addition of awnings, an extension on the north side (far end) and a second-floor added on the south (near camera) end.

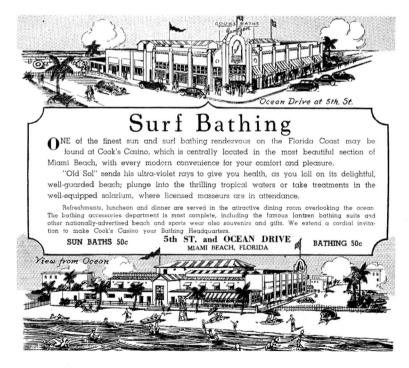

Ocean Drive at 5th. St.

Surf Bathing

ONE of the finest sun and surf bathing rendezvous on the Florida Coast may be found at Cook's Casino, which is centrally located in the most beautiful section of Miami Beach, with every modern convenience for your comfort and pleasure.

"Old Sol" sends his ultra-violet rays to give you health, as you loll on its delightful, well-guarded beach; plunge into the thrilling tropical waters or take treatments in the well-equipped solarium, where licensed masseurs are in attendance.

Refreshments, luncheon and dinner are served in the attractive dining room overlooking the ocean The bathing accessories department is most complete, including the famous Jantzen bathing suits and other nationally-advertised beach and sports wear also souvenirs and gifts. We extend a cordial invitation to make Cook's Casino your Bathing Headquarters.

SUN BATHS 50c **5th ST. and OCEAN DRIVE** BATHING 50c
MIAMI BEACH, FLORIDA

View from Ocean

For a Miami memorabilia collector, it just doesn't get any better than this, for this is the interior of the 3½- by 7½-inch opening to the 7- by 7½-inch Cook's Casino brochure issued circa 1935.

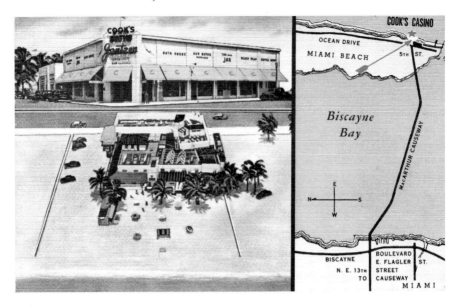

Cook's advertising featured a photograph of the front of the building at Fifth Street and Ocean Drive, a rendering of the facility from the ocean side and a map showing how to reach the building from Miami.

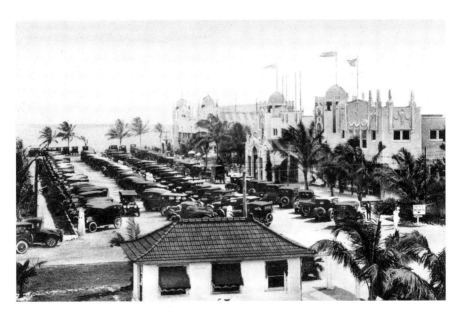

A stunning view of the Miami Beach/Fisher's Casino/St. John/Roman Pools/Everglades Club showing most of the facility, with Collins Avenue running from left to right behind the building in the foreground. The Roney Plaza had not yet been built.

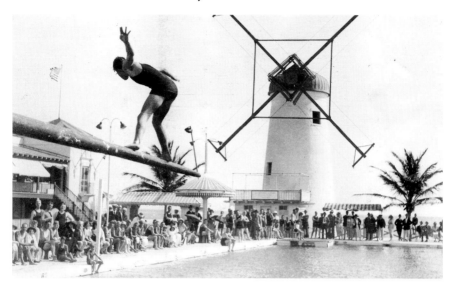

What stood out most at the Roman Pools was the windmill, which, depending on maintenance, sometimes actually operated. A Miami Beach landmark for many years, it should have been preserved.

The Ole Maestro

∽ BEN BERNIE ∽

and all the
Lads

★

Pepina *and* Naida

★

Loma Ruth *and* Connie Bee

★

Helene Daniels

are here nightly for your entertainment

For Reservations Phone 5-1924

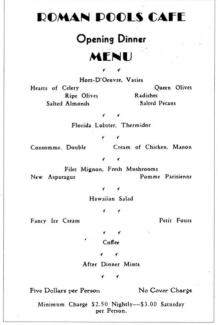

ROMAN POOLS CAFE

Opening Dinner

MENU

Hors-D'Oeuvre, Varies

Hearts of Celery Queen Olives
Ripe Olives Radishes
Salted Almonds Salted Pecans

Florida Lobster, Thermidor

Consomme, Double Cream of Chicken, Manon

Filet Mignon, Fresh Mushrooms
New Asparagus Pomme Parisienne

Hawaiian Salad

Fancy Ice Cream Petit Fours

Coffee

After Dinner Mints

Five Dollars per Person No Cover Charge

Minimum Charge $2.50 Nightly—$3.00 Saturday
per Person.

The opening dinner menu for the Roman Pools. This piece, with a gold front and back cover, may be one of a kind. It is not known if this was for the opening of the Roman Pools as a new entity or for the opening of a given season.

CHURCHES, TEMPLES
AND SCHOOLS (AND BEACH
WAS DYNAMITE!)

As noted in the preface to this book, one who has not lived on, grown up on, gone to school on and worked on Miami Beach, no matter how much study or research he or she has done or how hard he or she has attempted to immerse him or herself in the city's past, simply does not "get it." If you didn't go through the schools, interact with the Miami Beach kids, go to one of the two then junior high/now middle schools or go to the Hebrew Academy, Lear School, St. Patrick's or Beach High, then you are in the same place as you were when you read the giant billboards on Route 17—the Quickway—to and from the Catskills: "If you don't know from Manischewitz...you don't know from borscht." And, frankly, the people who did not grow up on Miami Beach and have written about Miami Beach's history don't know from borscht! And they never will.

As has been well recorded, the first church on Miami Beach was the Community Church on Lincoln Road, now under the longtime stewardship of Reverend Garth Reeves. That church is still, from time to time, referred to as "the gee-dee church" because, according to Jane Fisher, when she told Carl that his new city needed a church, he turned to her, once he got past his annoyance (he was a confirmed nonbeliever), and said, "Where do you want your G-d church?!" She told him that anywhere he wanted it would be fine, whereupon he marked a piece of land on Lincoln Road with a stick, gave her the property and told her to build her church. The church opened in 1921, and by the mid-1920s, Jewish people were conducting services in the Granat family–owned David Court Hotel at 56 Washington Avenue. Temple Beth Jacob, as noted in the introduction, first opened its doors to worshippers in 1929.

Members of the various faiths flocked to Miami Beach, not for religious reasons but because of business opportunities and weather, and Catholic

churches—including St. Patrick's, just south of Forty-first Street between Alton Road and Meridian Avenue, and St. Joseph's at Eighty-seventh Street and Byron Avenue—opened. St. Johns on the Lake, just north of Forty-seventh Street on Pinetree Drive, was a magnet for those of the Methodist faith, and Harold Cobb, one of the few non-Jewish boys at Miami Beach High, remembers his days at St. Johns fondly.

The Christian Scientists had a reading room on Pinetree Drive just south of Forty-first Street, and in the mid-1950s, Miami Beach Presbyterian opened a beautiful new house of worship at 7141 Indian Creek Drive, now a Jewish chabad.

As the years went on and the city grew, it became a magnet for those of the Jewish faith, with temples such as Knesset Israel opening on Washington Avenue and Fifteenth Street, Emanu-el at Seventeenth and Washington, Beth Sholom at Forty-second and Prairie Avenue, the North Shore Jewish Center (now Temple Menorah) at Seventy-fifth and Dickens Avenue and Ner Tamid at Eightieth and Tatum Waterway Drive, which, some years ago, merged with Rabbi Jory Lang's Temple Beth Moshe in North Miami.

Over the years, church and temple membership have risen and fallen, and Miami Beach, along with its churches of various denominations, now including a Mormon church at Sixty-ninth and Indian Creek Drive, has a goodly number of Orthodox Jewish institutions, including temples and chabads, many of the latter in the areas just north and south of Forty-first Street. In addition, Jewish people from Cuba have formed their own synagogues, and the Cuban-Hebrew Congregation on Normandy Isle is a thriving example. Suffice it to say, religion seems to be alive and well on Miami Beach, but fortunately, it appears to be of the tolerant and beneficent kind.

The schools on Miami Beach were special and the education superior. The early city- and chamber-issued descriptive booklets usually listed both public and private schools, and the names today, mostly long forgotten, are a revelation. A 1932 folder identifies the Coburn School, the Pelican School for Tots, St. Patrick's School and the Cate School, under the supervision of Major W.B. Cate. Only St. Patrick's survived, to be joined later by Yetta and Harold Malamud's Abbot Gardens Private School at Seventy-seventh and Abbot Avenue, the Lear School, Allegro, Manheimer, Drexel and Normandy Schools, as well as the Lehrman Day School of Temple Emanu-el at Seventy-seventh Street and Dickens Avenue and the Hebrew Academy.

Founded at 1 Lincoln Road in early 1947, the Hebrew Academy purchased the Methodist church at Sixth Street and Jefferson Avenue and moved there in 1948, remaining in that location until the 1963 move to a much larger, full

facility campus that offered kindergarten through twelfth-grade education. The new building on Pinetree Drive at Twenty-third Street was built, like Miami Beach High, the fire station and the Rakow Youth Center, on the grounds of the former city golf course.

Public schools were attended by the largest number of students. Elementary schools included South Beach (now South Pointe), Central Beach (now Feinberg-Fisher), North Beach and Biscayne, which opened in 1941 under the direction of greatly loved principal Ione S. Hill. Biscayne eventually served the burgeoning north beach area all the way to and including North Bay Village, Surfside, Bal Harbour, Bay Harbor Islands, Indian Creek Village and Sunny Isles. Relief for Biscayne's overcrowding (lawdy, those portables were awful!) would eventually come with the building of Treasure Island and Bay Harbor (now Ruth K. Broad–Bay Harbor K-8 School) Elementary Schools.

Children who attended the three schools from Forty-first Street (North Beach) south would go to Ida M. Fisher Junior High adjacent to Miami Beach High, while the children from Biscayne (and later, Treasure Island and Bay Harbor) would attend Nautilus Junior High at 4301 North Michigan Avenue, built on the site of Carl Fisher's polo fields and adjacent to Miami Beach's Polo Park. Students from both junior high (now middle) schools funneled into Miami Beach High, which, for many years, from the late 1940s until the early 1970s, was, with the singular exception of Bronx High School of Science, the number-one-rated academic public high school in America, with averages of between 88 and 94 percent of its students going to college. For those many years, Beach High was, in effect, a public parochial school, the huge majority of its students of the Jewish faith and the belief in education that was imbued in them serving in good stead as most of the school's students, Jewish or gentile, went to college.

Whether they were Typhoons or, beginning in 1960, Hi-Tides, Miami Beach High graduates are very special people. Indeed, the third incarnation of the school—a big, brand-new series of buildings on the site of the second Beach High at 2231 Prairie Avenue—will make certain that the Beach High tradition continues to imbue its students with the love for, and pride in, a great school. Beach *was* Dynamite! I certainly hope that it will continue to be.

THE BOARD OF PUBLIC INSTRUCTION

For the County of Dade

MEMBERS

H H FILER, CHAIRMAN DIST. 1
LEMON CITY

A G HOLMES, DIST. 2
MIAMI

S. E. LIVINGSTON, DIST. 3
HOMESTEAD

CHAS M FISHER, SECY & SUPT
MIAMI

Form B.

OFFICE OF THE
SECRETARY AND SUPERINTENDENT

MIAMI, FLORIDA

October 4, 1926

Mr. C. C. Carson:

You have been officially appointed ~~to teach in the~~ Supervising Principal _____

department, probably ____ grade, of the Miami Beach Schools for

a period of 9 months beginning on or about September 20th, 1926.

Your salary has been fixed at Five Hundred _____ Dollars

($ 500.00) per month. (Plus use of Cottage north of the High School Building)

The School Board reserves the right to transfer you to some other grade, subject or building if such is found necessary for the best interests of the schools.

It is understood that you now hold a valid Florida Certificate by which, together with your scholastic training and experience, your salary is determined.

In accepting this appointment it is understood and agreed that you will (definitely ally yourself with the State and National Education Associations by the close of your second month's service), comply with the rules and regulations of the school officials at all times, and faithfully and loyally discharge the duties of your position.

If you accept this appointment, please sign blank below, detach and, if possible, return same within ten days from date hereof.

Very truly yours,

Chas. M. Fisher
County Superintendent

a. K.

One of a kind, this is the first contract ever offered to a supervising principal of Miami Beach Schools. Dated October 4, 1926, the jurisdiction included an elementary school and Ida M. Fisher High School. (Ida was Carl Fisher's mother. A printing error changed her middle initial from G. [Graham] to M.) The high school remained Ida M. until the name was changed to Miami Beach High following the graduation from Fisher of the class of 1935, at which time Ida M. became a junior high school. A new building, adjacent to the original structure, housed the new high school. Note that the salary provided to Principal C.C. Carson was $500 per month, along with the use of the "Cottage north of the High School Building."

Published in February 1932 by the students of Miami Beach (most likely that school would become Central Beach) Elementary School, *Sunshine* was a student-written and illustrated, thirty-two-page, mimeographed magazine. The three copies known to be in existence today are cherished by their holder.

Dr. Elisha A. King, the church's minister emeritus, wrote in his book, *Planting a Church in a National Playground* (published in 1942), that Miami Beach Community Church opened on February 7, 1921, on land given by Carl Fisher at the southwest corner of Drexel Avenue and Lincoln Road. The church, Miami Beach's oldest house of worship, remains an integral part of Miami Beach life.

St. Patrick's Church, at Thirty-ninth Street and Alton Road, is Miami Beach's oldest Catholic church.

Miami Beach Presbyterian Church, shortly after opening. The building is now a Jewish chabad and school.

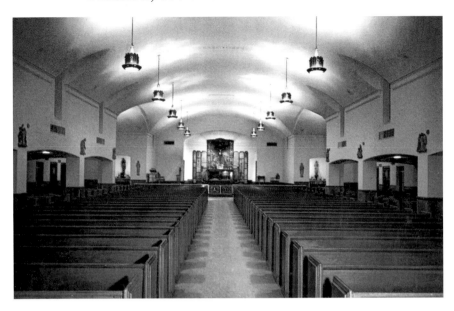

Above: The interior of St. Joseph's Catholic Church at 8670 Byron Avenue.

Left: Miami Beach's Holocaust Memorial honors the victims of World War II nazism. *Courtesy Jeff Weisberg.*

On January 27, 1957, St. Johns on the Lake Methodist Church, at 4764 Pinetree Drive, was photographed. Strongly active in the community today, the church sponsors numerous concerts and art exhibits throughout the year and is led by an enlightened and open-minded clergy.

At Temple Beth Sholom, Rabbi Gary Glickstein (second from left) is joined by (from left) Rabbi Robert David, Nancy Kipnis, Rabbi Gayle Pomerantz and Cantor Steven Haas. *Courtesy Temple Beth Sholom.*

Above: The original Miami Beach High, home of the Typhoons.

Left: Handsome? Bennett Bramson wasn't just handsome. He was, more importantly, a kind and loving person who was—and is—loved by all who knew and know him. Shown graduating from pre-kindergarten school at Stillwater Park, he would go on to Biscayne Elementary, Nautilus Junior High and Beach High, where he would become vice-president of his 1970 class, best all-around in the 1970 *Hi-Tide* yearbook and service club sweetheart. In Miami Beach, Bennett is his brother's claim to fame.

Standing next to and sitting in a 1960 or '61 convertible in front of the then new Beach High is the 1961–62 cheerleading squad. Not only were the Beach High cheerleaders beautiful but they also sounded, unlike the deep-voiced cheerleaders of every other school in the county, like girls, with sweet, melodious voices. Della Salzberg is sitting on the hood, while Iris Slofsky is at far right. Kneeling in front of the car are Suzie Friedman (left) and Florrie Eisenstat (right). In the car are Harriet Abramson, Ellen Lansburgh, Natalie Fial, Judi Lang, Nancy Finkel and Penny Pearl. This is the second Miami Beach High at Prairie Avenue and Dade Boulevard, home of the Hi-Tides since the move from Drexel Avenue in 1960. That school (1960–2008) has been razed, and a completely new Beach High was built in its place, the third incarnation of a great school.

A South Beach Elementary School cap or beanie. *Courtesy Myrna Bramson.*

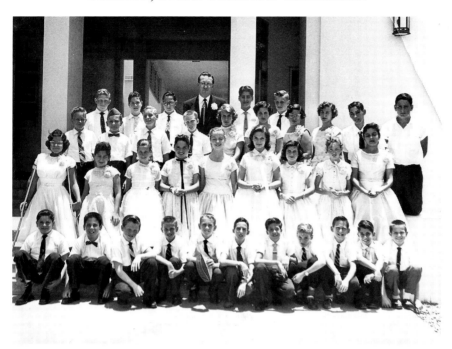

Donald Poe's sixth-grade Biscayne Elementary School class in their "graduation" picture, June 1956. Most of them went on to Nautilus Junior High the following September, and at least fifteen of those shown graduated from Miami Beach High in June 1962, no few of them remaining in touch and continuing friendships begun, in some cases, more than fifty-five years ago. *Bottom row, from left*: Marvin Kerstein, Seth Bramson, Barry Bratter, Robert Salkin, Bill Mickelberry, Charlie Mendelson, Ricky Mannen, Barry (?), Mark Romer, Bill Grayson, James Kennett. *Second row, from left*: Carolyn Miller, Barbara Berkowitz, Lynn Frohman, Judy Lapof, Taylan Cox, Barbara Courshon, JoAnn Warren, Kathleen Rank, Nancy Ramirez. *Top row, from left*: Charles Steiren, Gary Michaels, John Yenches, Ricky Lehman, Nathan Prichason, John Sootin, Tilden Zane, Mr. Poe, Barbara Jaffe, Bob Blumenkrantz, Helen Marks, Richard (?), Karen Michaelson, Carole Strauss, Charles Silvers, Bob Payton.

Opposite above left: Beach High's Twentieth Commencement was held on Thursday, June 6, 1946, at Flamingo Park, most likely in the band shell. There were 183 members in the class. Presenting the diplomas to that class was 1930 Fisher graduate Milton Weiss, whose wife, Cecile (Cecee) Alexander Weiss graduated from Fisher in its next-to-last pre–Beach High class of 1934. Milton's mother, Rose, is often referred to as "the mother of Miami Beach," while his sister, Malvina, would attain a highly placed position with the Dade County School system. Milton and Cecee's daughter, Alexa, would also go to Beach High, graduating in the class of 1962. *Courtesy Stuart Jacobs.*

The Twentieth Annual Commencement

Flamingo Park, Thursday, June 6, 1946, 8:00 P. M.
MIAMI BEACH SENIOR HIGH SCHOOL

1950

ZEPHYR
THE LEAR SCHOOL
MIAMI BEACH FLORIDA

Above right: Lear School's annual was the *Zephyr*. The 1950 yearbook featured the seven members of the graduating class, among them well-known "man about town" Sheldon B. Miller, who was the only male in that class.

Right: The "new" (opened in 1963) campus of the Hebrew Academy was a dream come true for the school. In September 1961, the academy announced the beginning of construction on the new facility, at Twenty-fourth Street and Pinetree Drive.

The
HEBREW ACADEMY
NEWS

SEPTEMBER, 1961 ELLUL 5721

At Long Last

After seven long years of battle with overwhelming forces which kept us confined to our old and inadequate quarters on Sixth Street, we have finally, with the aid of the Almighty, begun construction of our new buildings on Pine Tree Drive and 24th Street. As of this writing, the foundation is being laid, and soon enough we shall see the structure rise.

This did not come easy. Much pain, heartache and hard work were the ingredients that brought us to this level of success. The sacrificial devotion of a handful of men and women who never flinched or slackened their efforts served to inspire countless others who otherwise may have wavered. Never have so few done so much for the advancement of Torah education in our community.

Our heartfelt appreciation and genuine thanks are here extended to the contributors and workers in our Campaign. Extra special thanks, however, go to the members of hte Building Committee, whose ceaseless efforts have put us on the road to construction. These are the men, who behind the scenes, labored tirelessly:

Leonard Rosen, Chairman
Jerome Bienenfeld
Charles Charcowsky
Irving Firtel

Welcome!

The need for a news media to keep abreast of the many and varied activities eminating from the school, the Hebrew Academy Women and the PTA, has long been felt.

The need becomes all the more urgent as the construction of our new buildings moves forward at a rapid pace. To be informed of the progress we are making is the first requirement for more active participation by all of us.

We welcome the Hebrew Academy News and hope that it will spur us all on to greater accomplishments.

Harry Genat
Maurice Goldring
Louis Merwitzer
Samuel Reinhard
Maurice Revitz

Let us keep pulling together until the job is completed. Ours will be the privilege and "Zechus" to raise the level of Torah and Jewish leadership in our community to the highest degree of accomplishment.

As we approach the New Year, let us pray that it will be a happy and healthy year for all of us and that it will see the fulfillment of all our dreams.

B. I. BINDER, President.

Campaign Report

We are happy to report that we have close to $800,000 in pledges towards our Million Dollar Building Campaign goal. Chase Federal and Miami Beach Federal have jointly granted us a construction loan of $500,000, with the understanding that we are to raise an additional $300,000 in cash to make up the difference between the construction loan and the construction costs.

We now have cash in the bank, $125,000. We need an additional $175,000. This money is needed NOW to guarantee that there will be no interruption in the construction.

This is the time when you can do us the most good. This is the time when all your love and devotion to the Hebrew Academy can be translated into concrete action. You can now, by turning your love into dollars, make the building go up.

Send us your check on the pledge you made, whether you made a previous payment on your pledge or not.

You help us now and the good Lord will help you on the New Year with health, happiness and prosperity.

LOUIS MERWITZER,
Campaign Chairman;
LEONARD ROSEN,
Building Committee Chairman.

MIAMI BEACH JUNIOR - SENIOR HIGH SCHOOL
HOME ECONOMICS DEPARTMENT
PRESENTS

"Alice in Fashionland"

Sponsors
Miss Anna Blattner
Mrs. Margaret Hogsett
Mrs. Irma Morris

May 1, 1951
OLIN C. WEBB, PRINCIPAL

On May 1, 1951, with Olin C. Webb as principal, the Miami Beach Junior (Fisher) and Senior High's Home Economics Department presented "Alice in Fashionland," a look at the fashions of the time, with students modeling housecoats and pajamas, school clothes, blouses and skirts, beach and sports clothes, tailored clothes, afternoon sheer cotton and date dresses. That, along with the art exhibit following, must have made it quite an evening. *Courtesy Luba Kirsch.*

Miami-Dade Police retired deputy director Irving (Red) Heller.

Biscayne Park Police chief
Mitchell Glansberg.

Bill Rogers.

Above left: Federal district judge Alan S. Gold.

Above right: Hannah Diamond Lipton.

Left: The late Dr. Richard L. (Dick) Schwarz.

RESTAURANTS
AND CLUBS

As with the hotels, there is enough material of, on and about the restaurants, nightclubs, public (entertainment) and private (bathing, dining, golf) clubs and their histories to fill a book on either topic. Indeed, a separate book on either subject would fill a major void in the city's history.

The first restaurants on Miami Beach were those in the casinos, as discussed in chapter six. Three of the casinos (Smith's, Hardie's and Fisher's) were large enough to have served full meals, and while it is known that Joe Weiss started feeding the public at Smith's Casino in 1913 and that Joe's on Biscayne Street became the first freestanding public dining establishment on the beach in 1918 (see chapter three), very little else is known about how or where visitors to Miami Beach and its predecessor entities dined in the earliest days.

The available literature, including books, articles and other references, makes scant mention of the earliest restaurants or clubs. Fortunately, in Ann Armbruster's *The Life and Times of Miami Beach*, she notes that "if you were staying for the season (in the 1930s)…you probably ate out on Washington Avenue." Among the long-gone restaurants and cafeterias named are Manny's; Winnie's Waffle Shop on Twenty-third Street and Collins; Hoffman's and the Waldorf Cafeterias; and Teddy's on Ocean Drive between Tenth and Eleventh Streets, which advertised seven courses for sixty-five cents. Longtime beachites will, of course, remember the Pig Trail Inn and George's Fried Chicken, both on Fifth Street, but the more recent eateries are certainly remembered by a greater number of people, as, sadly, many who grew up on or lived on the beach in the 1930s are no longer with us.

With the in-pouring of tourists and the home buying and apartment renting of residents and full-season visitors, it was obvious that Miami

Beach needed restaurants, as well as entertainment venues. As the city grew, Fisher and his friends began to believe that they also needed private clubs for the social elite, which did not include those of the Jewish faith. Carl built LaGorce Country Club (named for his friend Jack LaGorce) and helped to promote the idea of the Bath Club, a dining and bathing club on the oceanfront at Fifty-ninth Street. Some years later, a group of well-heeled individuals would split off from the Bath Club and form the Surf Club, in Surfside, but that story is included in my book *33154: The Story of Bal Harbour, Bay Harbor Islands, Indian Creek Village and Surfside*, also published by The History Press.

Eventually, restaurants and nightclubs began to open, and service clubs, such as Kiwanis, Rotary, Masons and Shrine formed. Veterans groups were active on Miami Beach, with American Legion, Veterans of Foreign Wars (VFW) and Jewish War Veterans all having posts. The surviving group, VFW 3559, retains its post on West Avenue and remains strong and active today, participating in all Miami Beach civic and patriotic activities.

It is likely that the first "Jewish-style" eatery on the beach was, according to an August 17, 1973 article in the *Miami Herald*, the Rosedale Deli on Washington Avenue and Fifteenth Street. Opened by David Boris (sometimes spelled "Boras") sometime in the early 1920s, the restaurant moved to Miami several years later, after David Alper became his partner. The Rosedale, then, was the first of a long list of wonderful New York— and Jewish-style restaurants, reading like a who's who of Greater Miami food memories and including, among others, Al Nemets', Mammy's, Pappy's, Manny's, Junior's, Wolfie's and Pumpernik's.

But dining on Miami Beach was much more than just the delis. There were marvelous "Jewish-style" cafeterias, including, among others, the Governor, the Ambassador, Dubrow's and Holiday. "Oy, was that eating!" And fine dining abounded, with names that bring memories flooding back: The Famous, Gray's Inn, Chandler's, Fan and Bill's, Embers, Hickory House, Gatti's, Picciolo's, Jimmy's Just a Hobby, Italian Village, Old Forge, Le Parisien, Cathay House, Royal Hungarian, Park Avenue, Omar's Tent and many more. There were other places that evoke warm reminiscence, from hotel restaurants, casual dining establishments such as Curry's and coffee shops such as Parham's to snack bars, pizza places, Chinese restaurants (long before Thai, Indian, Japanese or natural foods) and drive-ins, including Colonel Jim's, and hamburger/hot dog places such as Fun Fair, both in North Bay Village but "close enough for government work."

The nightclubs, for the most part, also served food, in varying degrees of quality. Coming readily to mind are the Beachcomber, Alan Gale's, Ciro's,

The Story of Miami Beach

Copa City, Cotton Club, Club 22, Bill Jordan's Bar of Music and Kitty Davis Airliner Club. Burlesque was readily accessible, with entertainment emporiums including (among others) Life Bar, Place Pigalle, Paddock Club and Minsky's. There was also high-grade adult entertainment at Latin Quarter on Palm Island and the Chez Paree, both with elegant, seminude shows, and the Circus Club and the Jewel Box, which featured female impersonators. While each generation thinks its time on Miami Beach was "the best," each decade or era brought—and brings—its own marvelous memories.

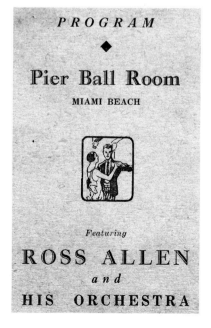

There are so many pieces of Miami Beach memorabilia for which the expression "It just doesn't get any better than this" can be used, and this and the next three images are just such items. This is a June 25 (must be mid- to late 1920s) golf bag tag from the bag room at Bay Shore (now Miami Beach) Golf Club. John J. Brophy was the professional shown in many of the Fisher-era photos, including the nationally syndicated picture of him on the back of Rosie, Carl Fisher's elephant.

The Pier Ball Room was at the ocean end of the pier at First Street and Ocean Drive. For many years a grand entertainment venue, today the pier, rebuilt several times, hosts nothing but fishing, with not even a plaque commemorating its former glory days.

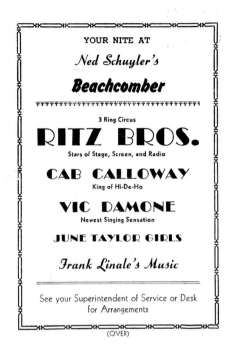

This page: Two incredibly rare pieces from the Beachcomber, one the menu (on the back of the card), with the featured entertainment (Ritz Bros., Cab Calloway and Vic Damone) on the front, and the other the advertising card for a short appearance by fabled ecdysiast Lili St. Cyr.

Marie (Mother) Gross was known as "Miami Beach's First Nighter," and from the late 1940s until her death in mid-October 1964, she was Miami Beach's premiere socialite. Usually accompanied by her twin sons, Willie and Monroe, Mrs. Gross was probably the only Jewish person welcomed at the Bath or Surf Clubs or LaGorce Country Club during the anti-Semitic years. (Maybe they didn't know!) Living in her later years at 4925 Collins Avenue, she rarely missed a theatrical or sporting event first night. Upon her death, Bill Jordan sent her son Monroe this eloquent letter of condolence.

BILL JORDAN'S Bar of Music

"The Bar that Music made Famous"

PHONE 531-5439
427 - 22ND STREET
MIAMI BEACH 39, FLORIDA

Mr. Monroe Gross,
Executive Apts.,
4925 Collins Ave.,
Miami Beach, Fla.

Dear Monroe,

There is little anyone can say in your hour of grief, to assuage the pain in your heart. Thus, I waited until today to write a short note. It is comforting to know how many thousands of people loved Mother. She had more friends and admirers than any single person I have ever known. I dont have to tell you the feeling I have in my heart, as I particularly really loved her as though she were my own Mother. I shall especially miss giving her annual birthday party at the Bar of Music on Thanksgiving. But she will be with me in spirit. I am happy and very proud to have been fortunate enough for Mother to have returned this same wonderful love and admiration to me. Over the years, as we travel on thruough life, we are lucky indeed to have had the good fortune to know and to admire and to love such a wonderful and kind and thoughtful lady. My wife, Allene, joins me with our sincere sympathy.

Your friend,

Bill
Bill Jordan.

LA GORCE GOLF CLUB
BAY SHORE GOLF CLUB

SEASON

1931 - 32

MIAMI BEACH • FLORIDA

Fisher built and operated all three of Miami Beach's golf courses, but in 1939, when the restriction on recreational use only for the course south and east of today's Miami Beach Golf Club (formerly Bay Shore) expired and the land was converted to commercial use north of the north side of Lincoln Road, the city purchased Bay Shore from Fisher Properties, making it a municipal course. In 1931–32, when both La Gorce and Bay Shore were Fisher owned, the clubs jointly published this 3 3/8- by 6 1/8-inch, twenty-four-page, heavy stock cover booklet with rates, rules, photographs and club information for both clubs. The 1931–32 season was Bay Shore's tenth and La Gorce's fifth.

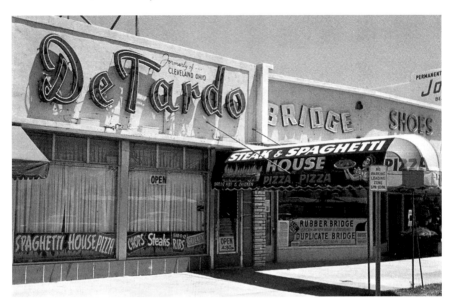

Above: More fond memories. DeTardo, 1211 Seventy-first Street, was a favorite, along with Franklin's 12–17 Steakhouse just down the block, for many years.

Left: The Rocking MB Lounge, on Collins Avenue, was owned by Bucky Gray and was, for years, a local hangout.

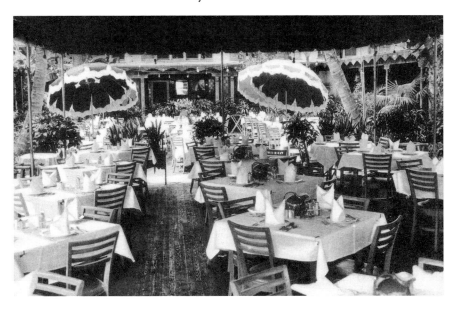

Above: Louis Patio Grill and Air-Cooled (not air conditioned) Dining Room was at 731 Lincoln Road, on the north side of the street.

Right: Did we love it or did we love it? Lobster from the tank, great Italian food, sausage, chicken, peppers and wonderful desserts made Picciolo one of the beach's favored places.

Sam & Dorothy

Picciolo

ESTABLISHED 1936

Dessert Menu

ALL PASTRIES, ICE CREAMS, ITALIAN ICES
AND BAKING ARE MADE ON OUR PREMISES.

136 COLLINS AVENUE
MIAMI BEACH, FLORIDA

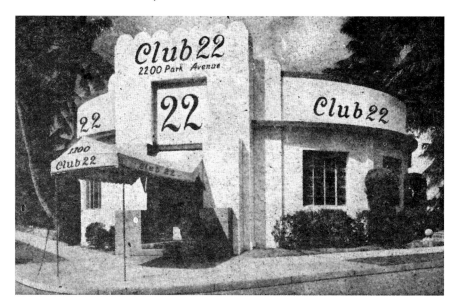

Club 22, at 2200 Park Avenue, right on the corner of Twenty-second and Park, later became El Chico.

Hackney's opened on Miami Beach in the late 1920s on Ocean Drive. Sometime in the late '30s, it moved to Alton Road and eventually to 133rd and Biscayne, from which location, in the mid-1950s, it finally disappeared from the Miami dining scene. This incredible piece is actually an ink blotter.

Le Parisien
FRENCH RESTAURANT

PRESENTS

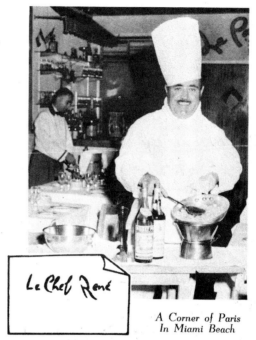

Right: Dining at Le Parisien, just west on the same block as Andy Somma's Old Forge, was always an adventure in French cuisine.

Below: Bouche's Villa Venice, at Twenty-third Street and the ocean, was a mix of statuesque showgirls, well-heeled customers and high-priced dining.

Le Chef René

*A Corner of Paris
In Miami Beach*

474 Arthur Godfrey Rd. (41st St.) — Miami Beach

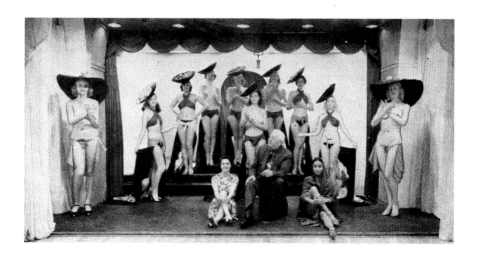

THE FOUR WAY TEST

1. *Is it the Truth?*
2. *Is it fair to all concerned?*
3. *Will it build good will and better friendships?*
4. *Will it be beneficial to all concerned?*

PAST PRESIDENTS
MIAMI BEACH ROTARY CLUB

Club #4437 • Organized Nov. 1937

August Geiger	1937
Bruce MacIntosh	1938
Marvin Ebelmesser	1939
Chas. L. Clements	1940
John Bromley	1941
John D. Montgomery	1942
Sam R. Becker	1943
W. Vincent Farrey	1944
Chauncey Eldredge*	1945
Eugene W. Groover	1946
Ike N. Parrish	1947
Irwin R. Waite	1948
Stuart L. Moore	1949
Walter Grundy*	1950
Harold Couch	1951
D. Richard Mead	1952
Frank Smathers, Jr.	1953
Edward T. Bedford	1954
Richard S. Pomeroy, III	1955
*Deceased	

MAKE UP YOUR ATTENDANCE
on

Monday	12:15	Allapattah—Edith & Fritz Rest.
	6:45	Dania—Sea Shell Restaurant
Tuesday	12:15	S. Miami—Dixie Belle Inn
	12:15	Hollywood—Rotary Club Bldg.
Wednesday	12:15	Miami N. Shore—Miami Shores C.C.
	12:15	Coconut Grove—La Casita Rest.
	12:15	Homestead—Legion Bldg.
	12:15	Miami Springs—Jerry's, LeJeune Rd.
Thursday	12:15	Miami—Columbus Hotel
	12:15	Bal Harbour—Balmoral Hotel
Friday	12:15	Coral Gables—C. G. Country Club

THE PROGRAM OF ROTARY

Rotary's program is to encourage and foster the "Ideal of Service" as a basis of worthy enterprise and, in particular, to encourage and foster:

The development of acquaintance as an opportunity for service;

High ethical standards in business and professions; the recognition of the worthiness of all useful occupations; and the dignifying by each Rotarian of his occupation as an opportunity to serve society;

Miami Beach Rotary Club

Meets Tuesdays, 12:15

Delano Hotel, 1685 Collins Avenue

Phone JE 8-7881

OFFICERS

Samuel F. Knowles	*President*
Richard S. Pomeroy, III	*Vice President*
John H. O'Brien, Box 1107, North Miami	*Secretary*
Robert A. Peterson	*Treasurer*

DIRECTORS

Richard S. Pomeroy, III, Truly Nolen, Howard L. King, Richard L. Poor, Arnold Levy, C. W. (Pete) Chase, Jr., Joseph E. Crawley, Paul Wimbish, Harold Jarvis, Robert Peterson, Vincent Farrey.

COMMITTEES

HAROLD JARVIS, Chrm.	CLUB SERVICE
Joseph Gatti	Attendance
Richard S. Pomeroy, III	Classifications
James P. Wendler	Club Bulletin
Lou Wolfson	Fellowship
C. W. Chase, Jr.	Magazine
Secret	Membership
Moe Rippa	Good Cheer
Truly Nolen	Program
Howard L. Clyne	Public Information
Vincent Farrey	Rotary Information
Charles Owen	Grandfathers' Club

RICHARD L. POOR	VOCATIONAL SERVICE
ARNOLD LEVY	COMMUNITY SERVICE
REX KING	INTERNATIONAL SERVICE
	United Nations
	Intrnl. Cont acts
	Intrnl. Student Projects

EARL MASON	SGT.-AT-ARMS

The service clubs were numerous and attracted beachites in large numbers. The Miami Beach Rotary's 1956 membership list of seventy-nine Rotarians included, among others, Ed Fogg of Land O'Sun Dairy and later a county commissioner; Beach High grad and famed exterminator Truly Nolen; orthodontist Meyer Eggnatz; banker and accountant Leonard Abess; architect August Geiger; Colonel Mitchell Wolfson of Wometco; and Harold K. North, Miami Beach city ticket agent of the Florida East Coast Railway.

THE HOTELS

It is well known, through the various books and publications on and about Miami Beach, that the first hotel was Brown's, a wooden two-story building opened in 1912 on the west side of Ocean Drive, just north of First Street. Brown's offered bedrooms on the second floor and kitchens on the first floor. Ann Armbruster states that they were "available in combination or singly," but neither she nor any other source is clear as to whether there were sleeping rooms on the first floor or just kitchens.

In 1914, Carl Fisher built the first luxury hotel, the Lincoln, placing it on the southwest corner of Lincoln and Washington. Its lobby filled with stuffed alligators and moose heads, the homey and rustic property extended a full block to Drexel Avenue. With World War I came a move toward conserving and saving, hence vacations were reduced to a minimum. But with the signing of the Armistice in November 1919, America, weary of the war, was ready for a change of lifestyle.

In 1919, Carl announced plans to build a hotel for those who could afford the elegant life and had the means to resort properly. Naming it the Flamingo, it was the first of the three massive Biscayne Bay–fronting hostelries that included the Floridian and the Fleetwood. Charles S. Krom was selected as manager of the hotel, and following a private party on New Year's Eve 1920 and its formal opening on January 1, 1921, Krom would serve as the Flamingo's manager for twenty-eight seasons. Meanwhile, in 1920, the Ansonia, the first apartment building north of Fifth Street, opened.

In 1921, as noted in chapter five, the Wofford Hotel opened. That same year, the Nemo, at First and Collins, built by the family of pioneer beachite Myra Farr, opened as the first Jewish-owned hotel on Miami Beach. In 1924, Fisher opened the Nautilus Hotel, a massive building with four wings in the

shape of a Greek cross. Connected to the hotel were two islands, Johns and Collins, paying tribute to the pioneer. One would eventually become a fine residential island with large private homes, while the other would be the site of the hotel's putting green and, later, its swimming pool and cabana club. Both islands have been subsumed and are now part of the hospital property at Forty-third and Alton.

Also opening in 1924 was the massive Deauville Hotel, then way up north on the beach at Sixty-seventh Street and Collins Avenue. Going through several owners, the hotel would later become the MacFadden-Deauville, operated by health and physical culturist Bernarr MacFadden. That hotel was the location of Miami Beach's largest swimming pool and highest diving board until it was sold to Sam Cohen in the mid-1950s, razed and replaced by a then modern Deauville Hotel.

The Pancoast, Fleetwood, Floridian, King Cole and Boulevard Hotels would follow; the Fisher hotel chain eventually included the Lincoln, Flamingo, Boulevard, Nautilus and King Cole Hotels. The Fisher Hotels offered fine dining, and "the Fisher people" (records today are sparse to nonexistent in terms of this type of information) designed a stunningly beautiful china pattern—a series of vignettes of Miami Beach scenes, including golf, polo and water sports, around the border of the dishes, with some of the pieces also featuring a vignette of the Montauk lighthouse. The china was back stamped "Carl G. Fisher Properties," and interestingly enough, though Fisher did not own the Fleetwood Hotel, that property used the same pattern, with a proprietary back stamp reading "Made Expressly for the Fleetwood Hotel, Miami Beach, Fla." Apparently, Fisher and the Fleetwood management had some type of operating agreement, at least for the dining services.

The grandiose Roney Plaza, built by N.B.T. ("Newt") Roney, opened at Twenty-third Street and Collins in 1925. In September of the following year, Miami and Miami Beach were struck with a horrific hurricane, a calamitous event that killed over four hundred people, brutalizing the casinos and much of Miami Beach and piling sand as high as the third floor at the Roney. Overcoming that event, the hotel would go on to serve as Miami Beach's premiere resort until the opening of the Fontainebleau in 1954. When the Fontainebleau opened, Roney general manager Duke Stewart and a number of his colleagues, including pool and cabana manager Jack Stubbs, moved over to the incredible Morris Lapidus–designed hostelry at Forty-fourth and Collins.

Another of the major 1920s hotels was the Blackstone, the first luxury hotel built by Jewish people (the Stone family), ostensibly to provide those of the Hebrew persuasion with a hostelry equivalent to those from which

they had been turned away (including many of those noted above) due to the anti-Semitism of the times that allowed hotel operators to pick and choose their guests. (For a complete discussion of that issue and problem, see chapter three of *L'Chaim! The History of the Jewish Community of Greater Miami*, also published by The History Press. That chapter is titled "More Than Forty Years of Restricted Clientele.")

While the 1930s put a damper on business, the art deco hotel building boom took hold, primarily on Ocean Drive and Collins Avenue. With the end of the Depression came World War II and the greatest boom in Miami Beach's history. The city served as the main training center for the U.S. Army Air Corps; with more than 60 percent of the nation's flyers receiving their training on Miami Beach, the government requisitioned most of the hotels for use as barracks and mess halls, with meeting rooms becoming classrooms. The Nautilus Hotel became a military hospital and, following the war, a civilian hospital. Servicemen (and women) did their drills and cadence marches on Collins Avenue, Lincoln Road and Washington Avenue, as well as on the golf courses and in the parks.

The end of the war brought a huge influx of former GIs back to the beach. The men (and women) opened businesses, built homes and became, among other things, hoteliers. Some of the hotels built following the war were the Delano, Allison, Lombardy, Casablanca, Saxony, Sans Souci, new Nautilus and many others, with the then pinnacle of Miami Beach hoteldom just a few years in the future.

In 1953, Ben Novack, after having betrayed his partner, Harry Mufson, in a business deal, took title to the fourteen-acre Firestone Estate at Forty-fourth and Collins. Hiring a young Morris Lapidus from New York (Lapidus agreeing to work barely at cost because he knew that the design of the hotel would "make" his name and ensure his legacy, which it did) as the architect, Novack opened the Fontainebleau to rave reviews in December 1954, with more than five hundred rooms. It was Miami Beach's greatest triumph to date, but an angry Harry Mufson, a true gentleman who had been bamboozled by Novack, hired Lapidus to design the Eden Roc. Not as grandiose as the 'Bleau, the "Roc," upon opening in 1955, quickly established its own niche as a great destination.

The Doral, Deauville and Carillon would follow, but without casinos, Miami Beach's hotels could not compete with Las Vegas. By 1966, with the vote of the city council several years earlier to rezone Collins Avenue north of the Eden Roc, the face and complexion of the hospitality industry on Miami Beach had changed forever. Today, the city's hotel industry is based around the hope that art deco hotels, a Ritz Carlton, a Loews and remodeled

older hotels such as the Fontainebleau and Eden Roc can bring back leisure travelers and conventions, but with an aging, outmoded convention center, and without casinos and their accompanying attractions, there is little hope that Miami Beach will again be the resort capital of the world or even a major player in the convention business.

While it is not *de rigueur* that a history of Miami Beach include a photograph of Brown's, the first hotel on Miami Beach, it is certainly nothing if not appropriate. This original photo was made by Edward E. Shepard, who was located at 108 Collins Avenue, and whose phone number was "641."

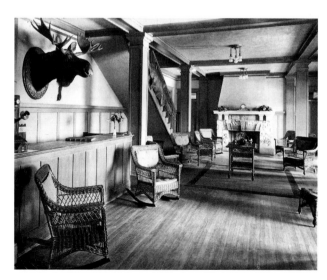

The lobby of Fisher's Lincoln Hotel featured moose heads and stuffed alligators. While the alligators are not visible in this incredible image made by photographer A. Kaufman, who worked from his home or studio at 125 Fourteenth Street (now Southeast Second Street) in Miami, one of the moose heads in the famously rustic inn certainly is!

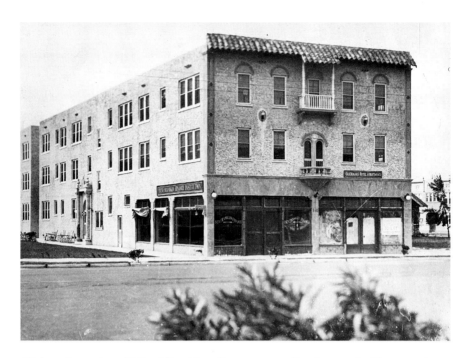

Glickman's, another of Miami Beach's earliest apartment/hotel properties (the name sign is on the right, above the whitewashed store front) was at 140; that street number was likely on Collins rather than Ocean Drive. I don't believe that it was on Washington Avenue. The entrance is on the left, where the telephone sign juts out by the pillar to the right of the door and guest easy chairs face each other across the walkway.

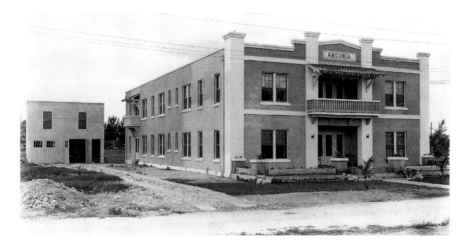

Ansonia, a concrete building and the first apartment building north of Fifth Street (complete with a two-car garage at left) is, because of its significance in time and place, worthy of inclusion.

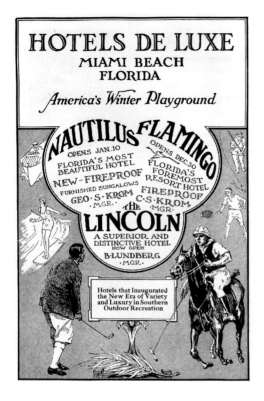

A Fisher Hotels advertisement from a national magazine. Since neither the Boulevard nor the King Cole are included, we know that this ad is likely for the 1924 season.

An 8½- by 11-inch, single-fold, four-page descriptive with five photos of Miami Beach and five of the hotel entices the prospective guest to join manager Frederic L. Abel at the King Cole, on Forty-seventh Street east of Alton Road at the north end of the polo fields, between January and April. Featuring all five of the Fisher Hotels, his casino and the Roney Plaza, the map on this piece is particularly significant because it shows the layout of the Miami Beach Golf Course down to Lincoln Road, of which the only part remaining today is the par-three course on Prairie Avenue north of the Beach High athletic fields.

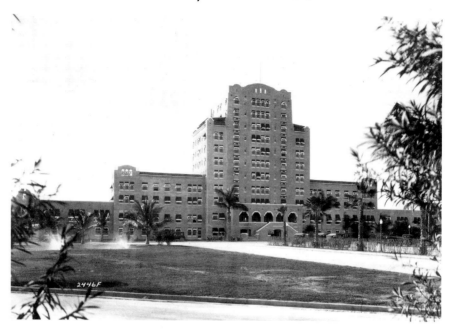

This page: The front of the newly opened Flamingo is shown, with minimal landscaping in place, while a tea dance is being held in the garden at the rear of the hotel. A careful examination of the dance photograph shows a photographer standing on a table in the open space between the trees in the right background.

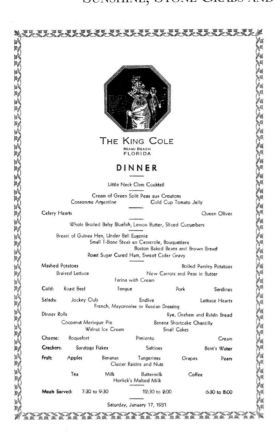

THE KING COLE
MIAMI BEACH
FLORIDA

DINNER

Little Neck Clam Cocktail

Cream of Green Split Peas aux Croutons
Consomme Argentine Cold Cup Tomato Jelly

Celery Hearts Queen Olives

Whole Broiled Baby Bluefish, Lemon Butter, Sliced Cucumbers

Breast of Guinea Hen, Under Bell Eugenie
Small T-Bone Steak en Casserole, Bouquetiere
Boston Baked Beans and Brown Bread
Roast Sugar Cured Ham, Sweet Cider Gravy

Mashed Potatoes Boiled Parsley Potatoes
Braised Lettuce New Carrots and Peas in Butter
Farina with Cream

Cold: Roast Beef Tongue Pork Sardines

Salads: Jockey Club Endive Lettuce Hearts
French, Mayonnaise or Russian Dressing

Dinner Rolls Rye, Graham and Raisin Bread
Cocoanut Meringue Pie Banana Shortcake Chantilly
Walnut Ice Cream Small Cakes

Cheese: Roquefort Pimiento Cream

Crackers: Saratoga Flakes Saltines Bent's Water

Fruit: Apples Bananas Tangerines Grapes Pears
Cluster Raisins and Nuts

Tea Milk Buttermilk Coffee
Horlick's Malted Milk

Meals Served: 7:30 to 9:30 12:30 to 2:00 6:30 to 8:00

Saturday, January 17, 1931

Dinner at the King Cole on Saturday night, January 17, 1931, was a culinary adventure, the menu featuring Little Neck clam cocktail, broiled baby bluefish or breast of guinea hen (with other entrée choices), potatoes, vegetables, a cold larder, salads, desserts, cheeses and fruits and ending with choice of beverage. As no price is shown, it is likely that the hotel, at that time, was operating on a full American dining plan, with all meals included in the cost of the room.

ROYAL PALM *Hotel*

ON THE OCEAN BETWEEN
LINCOLN ROAD and 15th STREET
MIAMI BEACH

Left and next page: Many of the hotels had their own luggage tags; those of the Rose and Unger Families' Royal Palm, between Lincoln Road and Fifteenth Street, and the original Nautilus (later a hospital) on Forty-third and Alton Road are shown here. The Strath Haven menu is dated Tuesday, January 24, 1939, and the complete dinner was a buck and a half!

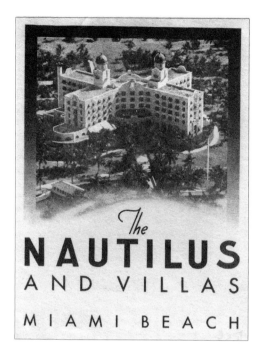

STRATH HAVEN HOTEL
On the Ocean
MIAMI BEACH, FLORIDA

	TUESDAY	
January 24, 1939	- One Dollar Fifty Cents	
	DINNER	

6:30 to 8:30
-

Honey Dew Melon	Fresh Crab Meat Cocktail
Canape of Anchovy	Chilled Papaya Juice

-

| Celery Hearts | Green Onions | Sweet Pickles |

-

Cream of Tomato	English Beef Broth
Cold Borscht	

-

CHOICE OF:

Filet of Snapper Flamande
Broiled Native Lobster Drawn Butter
Broiled Ham Steak and Eggs Country Style
Fricasse of Chicken w Wild Rice
Broiled Spring Lamb Chops w Bacon
Veal Cutlet Saute a la Holstein
Roast Prime Ribs of Beef au Jus
Cold Smoked Ox Tongue w Cucumber Salad

-

Home Fried Potatoes	Sweet Potatoes Imperial
Peas a la Francaise	
Cut Beans au Beurre	New Buttered Beets

Ladies Delight Salad
or
Boston Lettuce-Roquefort Dressing

-

Cherry Pie a la Mode	Strawberry Shortcake
Coconut Cake	Chocolate Parfait
Assorted Compote	Roquefort Cheese
Ice Cream	Sherbet

-

| Coffee | Tea | Milk | Buttermilk |

Ask for our Wine List

Room Service 25¢ Per Person

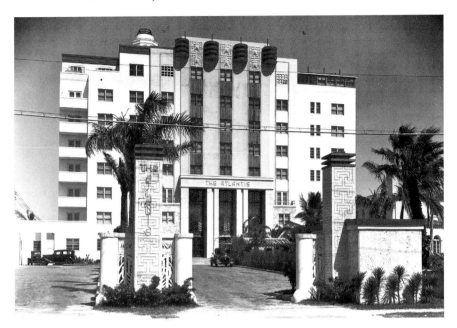

The Atlantis Hotel, facing the ocean at Twenty-seventh Street and Collins Avenue, was, at the time of its construction, a prime example of futuristic architecture. Photo taken by Claude Matlack, circa 1935. *Historical Association of Southern Florida collection.*

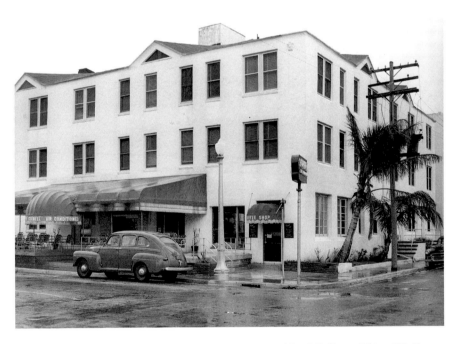

One of the beach's smaller hotels, the Cornell, on the west side of Collins at Thirty-fifth Street.

This page: Sometime in the 1930s, the Roney Plaza commissioned a series of paintings for its menus. These three are examples of Roney scenes featuring two children and their pup. The children are poolside under the umbrella, in a pedicab on the promenade north of the hotel and on the hotel's ocean walk, with the Roman Pools windmill to the south behind them and the Roney's oceanfront cabanas on the right.

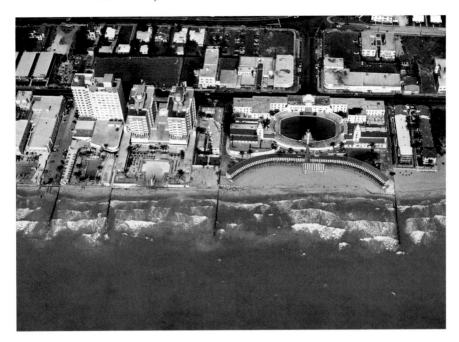

Photographed by Tierney and Killingsworth on May 15, 1952, this one-of-a-kind aerial view looks directly down at the MacFadden Deauville cabana club, pool and buildings. The twin towers of the Sherry Frontenac are to the left of the MacFadden, and to the left of the Sherry is the Monte Carlo. The street directly across from the front of the MacFadden Deauville is Sixty-seventh Street, with what would become Pumpernik's Restaurant on the right side of that street.

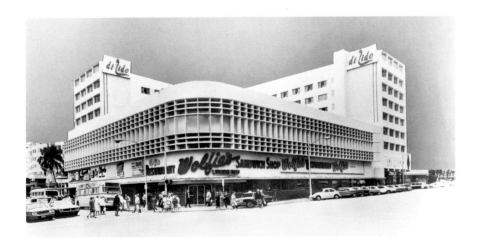

The diLido was built to wrap around the 1 Lincoln Road Building, original home of the Hebrew Academy and the Miami Beach YMHA, as well as the longtime site of Wolfie's Number One. The diLido cabana club was originally the site of the Sirkin family–owned Beach Club. Collins Avenue, looking north, is at left.

The Story of Miami Beach

Right: For New Year's Eve 1965, Café Pompeii at Eden Roc featured Jack E. Leonard and the Supremes, music provided by Val Olman and his orchestra. The precipitous decline of Miami Beach as a great resort and tourist destination would begin late in 1966, unquestionably due to the fact that casinos were prohibited in Florida by constitution rather than by statute, as well as the vile decision by the city council several years earlier to rezone Collins Avenue north of the Roc.

Below: The late Ben Novack's Fontainebleau spite wall is clearly visible at left. The Forty-sixth Street beach is at center, and one of the odious and onerous apartment houses is at right. Novack, in the act that sealed forever his reputation as a *farshtunkeneh*, not only built the Towers building with no windows on the north side but also left the massive gray, raw concrete wall facing the Eden Roc unpainted. The wall would only be painted white many years after Novack lost the hotel in bankruptcy; the buyer was a worthy successor to the Novack legacy.

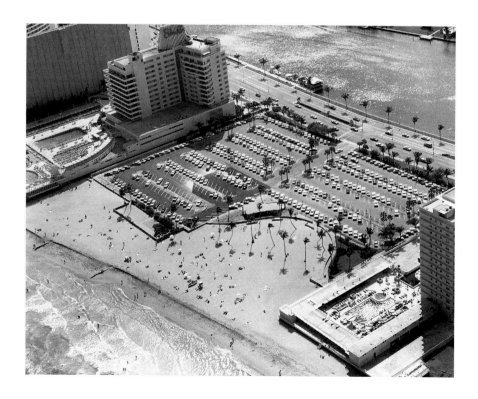

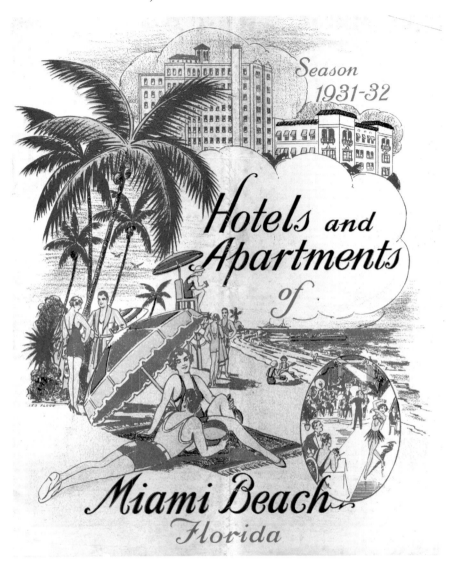

Season
1931-32

Hotels and
Apartments
of

Miami Beach
Florida

For the 1931–32 season, *Hotels and Apartments of Miami Beach Florida* was published as an advertising booklet filled almost entirely with hotel ads but including one article titled "Miami Beach Chief Among Gorgeous Resort Cities." The number of hotels using terminology such as "Restricted Clientele," "Gentile owned and operated," "Guest list suitably restricted" and "the clientele (of the Braznell) is a fine genteel people" is dismaying, if not surprising; all of those terms were meant to ensure that members of the Jewish faith understood not only that they were unwelcome, but also that they would not be allowed to register as guests in that particular hostelry. Fortunately, times have changed.

STREETS AND HOMES

This is not simply a chapter about the history of the streets and homes built on Miami Beach; rather, it is meant to show streets and homes that exemplify the uniqueness and beauty of Miami Beach. Certainly, the first "streets" on Miami Beach were today's Biscayne Street, Ocean Drive and Collins Avenue, with such thoroughfares as Lincoln Road, Washington Avenue and Alton Road following shortly thereafter. Very early Miami Beach maps show streets north of the first two southernmost east–west streets (Biscayne Street and Commerce Street) with names, but the numbering system for those east–west streets north of Commerce Street was adopted, according to Miami Beach historian Aristotle Ares, in 1912. Today, Miami Beach's street numbers run from 1st to 87th Terrace, the northernmost street on the beach. Surfside and Bal Harbour simply picked up the system, with the numbers continuing north from 88th Street in Surfside to 102nd Street in Bal Harbour.

Many of the early streets were named after places or streets with which Carl Fisher was familiar in Indianapolis, and several of those are noted in earlier chapters. While builders of the County (later MacArthur) and Venetian Causeway islands, as well as of the Sunset Islands, LaGorce Island, Normandy Isle, Normandy Shores and Parkview Island, had the privilege of naming the streets on those islands, several Miami Beach street names are particularly notable, especially those on Biscayne Beach and Biscayne Point.

Biscayne Beach was adjacent to property owned at one time by the Tatum brothers, land developers on both the Miami and the beach sides of Biscayne Bay. Their Miami Beach holdings, located mostly toward the north end of Miami Beach, were known as the Tatum Subdivision. Tatum Waterway Drive, which runs north beginning at the west end of Seventy-seventh

Street, just before that street crosses the two bridges to Biscayne Beach and Biscayne Point, is named for the brothers. The canal separating Biscayne Beach from the mainland portion of Miami Beach is, of course, Tatum Waterway. The two north–south streets on Biscayne Beach are Hawthorne Avenue, named for the poet, and Crespi Boulevard, perhaps named for a person instrumental in building Biscayne Beach but otherwise of unknown origin. Stillwater Drive, a two-lane street of private homes, juts west into Biscayne Bay from the north end of Hawthorne Avenue. A small park in a triangle—Stillwater Park—is at the east end of the drive of the same name and fronts on Hawthorne.

Growing up on Biscayne Point, which is actually three islands, I often wondered about the derivation of my street's name—Cecil Street—and its mirror image street on the south side of the island, Fowler Street, but it was not until reading *Fabulous Hoosier*, by Jane Fisher, that I learned that Cecil Fowler was a banker in Indiana and a close friend of Carl Fisher. Meanwhile, Noremac (Cameron spelled backward) Avenue is, also according to Mr. Ares, named for one of the developers of Biscayne Point. The person for whom Henedon Road, which connects the two sides of Biscayne Point, was named is still unknown.

As was done with Coral Gables streets, a booklet naming each Miami Beach street and its origin might be of historical interest, but for now, given time and space constraints, this much will, regretfully, have to suffice.

Homes on Miami Beach have ranged through the years from simple cottages to sumptuously elegant homes. North Bay Road, LaGorce Drive, Pinetree Drive and Alton Road are today filled with homes that range from upper middle class to stunningly beautiful. The various islands, particularly those on the MacArthur and Venetian Causeways, as well as on the Sunset Islands, part of Normandy Shores, LaGorce Island, Allison Island and Biscayne Point, abound with gloriously magnificent residences.

While it is not possible, in a single chapter, to show even a small percentage of Miami Beach's streets and homes, the next several pages will, at the least, give the viewer an idea of the city's beauty.

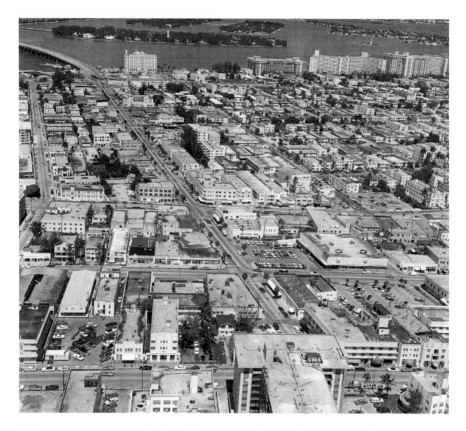

Fifth Street, prior to the widening. Fifth runs from Ocean Drive to the MacArthur Causeway and is the major street in this photo. Beginning just beyond the tall building in the front of the picture, it continues past Collins and Washington and goes on to Alton and the east causeway bridge. The Floridian Hotel is center left, the last of the three great West Avenue hotels to be torn down.

Today's Espanola Way was originally built as part of the Spanish Village, and a scene looking east toward Washington Avenue and the ocean is shown here.

Meridian Avenue, circa 1938.

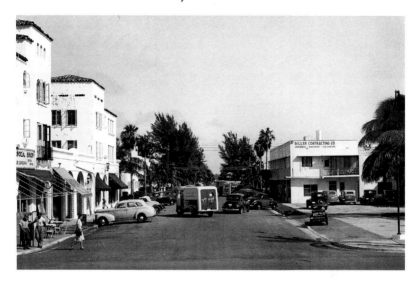

Michigan Avenue, north of Fifth Street; the Giller Contracting Company building is on the right, November 1941.

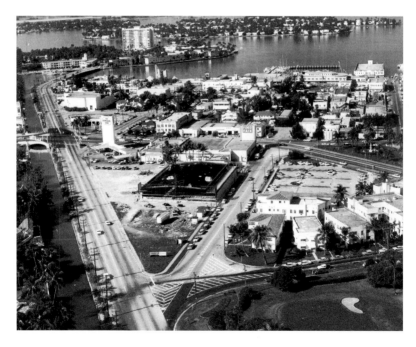

Looking west above Dade Boulevard and North Michigan Avenue on February 2, 1963, where it connects to Alton Road at right. The new Publix is under construction, with Food Fair directly behind it. The General Tire is center left on Alton Road, and only one out-of-place, sticking-out-like-a-sore-thumb high-rise has so far marred the once beautiful Belle Isle.

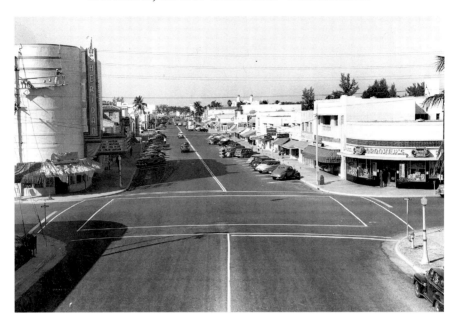

MIAMI BEACH'S
71st Street
BUSINESS CENTER

SEVENTY-FIRST STREET
PROPERTY OWNERS ASSN.
INCORPORATED

Above: Forty-first Street (Arthur Godfrey Road), looking west from Sheridan Avenue, circa 1950. Groover's Rexall Drugs is on the northwest corner, and the Sheridan Theater is on the southwest corner. Betty Hutton and Victor Mature were starring in *Red Hot and Blue*, and to a great extent, the street still looks the same.

Left: In October 1950, the Seventy-first Street Property Owners Association published this brochure, ballyhooing the benefits of locating a business on that street. An extremely rare piece, this is the only one I have ever seen.

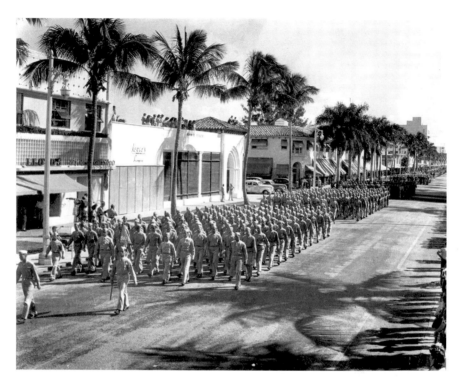

Although Lincoln Road has a large part of a previous chapter dedicated to it, this photo of the Army Air Corps men marching west on the north side of that fabled street must be included, as much for what it represents as for the fact that, while postcards of the troops in various scenes are relatively plentiful, original photographs of the men (and women) drilling on the streets are very rare. The photo must have been made in summer or early fall, as the stores, including Bonwit Teller behind the troops, are boarded up until the coming season. I am indebted to former Miami Beach mayor Harold Rosen for graciously loaning me this and several other marvelous images.

This page: Lest there be any continued argument or nonsense, the famed "coral rock house" at 1030 Washington Avenue is incredibly historic and must be preserved. Owned by Henri Levy, the builder of Normandy Isle and the southern one-third of Surfside, including Biscaya Island, this house, with both front and rear views shown, is one of Miami Beach's few existing links to its storied past. Shown at the rear of the house, Rose Levy is seated at the table at right, with her older daughter, Clemence, standing next to her, while baby June is playing near what appears to be a carriage. *Courtesy June Levy Newbauer.*

A very rare view, this building at 611 Collins Avenue was home to Miami Beach's government prior to the opening of the then new city hall at Eleventh and Washington Avenue. *Courtesy City of Miami Beach.*

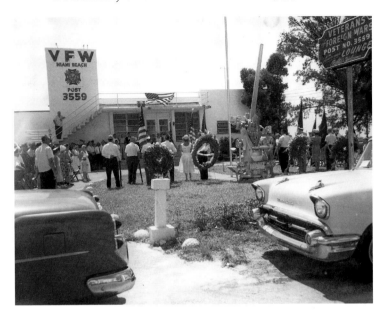

This page: A house of honor, Miami Beach's Veterans of Foreign Wars (VFW) Post 3559 opened with a grand ceremony in the early 1950s. Sometime in the early 1960s, Post Commander Aristotle Ares, far left, with wife Diane, second from left, are joined by another couple at a Post event. *Courtesy Miami Beach VFW Post 3559.*

Fisher's magnificent second Miami Beach home; this one is on North Bay Road just north of Fifty-first Street, a block west of the monument honoring him.

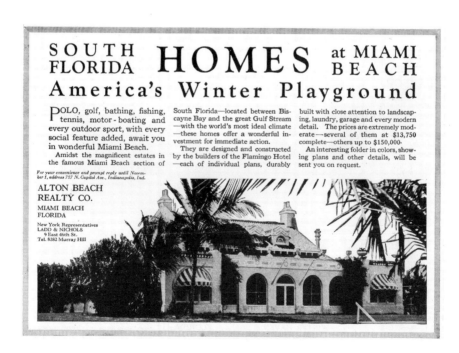

From page seven of the November 1921 issue of *Country Life* magazine comes this Alton Beach Realty Company advertisement for "Homes at Miami Beach/America's Winter Playground." It is interesting to note that the address to be used in order to receive a prompt reply was in Indianapolis, likely Fisher's office there.

ISLANDS IN THE SUN

As most people who come to or live on Miami Beach know, the city is actually made up of a number of islands. Those that are residential—except for Normandy Isle, created by Henri Levy in the early 1920s—are without commercialization, and no stores or businesses are permitted to intrude on the quiet and usually elegant residential living.

The MacArthur Causeway islands include Palm, Hibiscus and Star. Venetian Causeway islands are Belle Isle, Rivo Alto, DiLido and San Marino. Between the two causeways is Monument Island, the Henry M. Flagler Memorial built by Carl Fisher to honor the greatest single name in Florida history. Contrary to what some uninformed tour guides on Miami Beach tell visitors, the men never met.

The Sunset Islands, reached via bridges from Alton Road or North Bay Road, are numbered one through four. Farther north, several blocks past Sixty-third Street, is the entrance to LaGorce Island, and extending north from Sixty-third, just west of Indian Creek, is the single-family home section of Allison Island.

Reaching Seventy-first Street, one turns west to Normandy Isle and Normandy Shores, the latter accessed by bridges from Normandy Isle. At Seventy-third Street and Dickens Avenue, one can enter Parkview Island. Going north on Dickens to Seventy-seventh Street and then turning west, the resident or visitor heads first to Biscayne Beach and then to Biscayne Point (for some years in the 1930s the city's police pistol range). Both islands are noted in the previous chapter. Stillwater Drive, also previously named, is not an island; rather, it is a peninsula, with beautiful homes on the one street that reaches the end of the peninsula.

There are, of course, other islands in the suburbs, and those will be mentioned in chapter thirteen.

The Story of Miami Beach

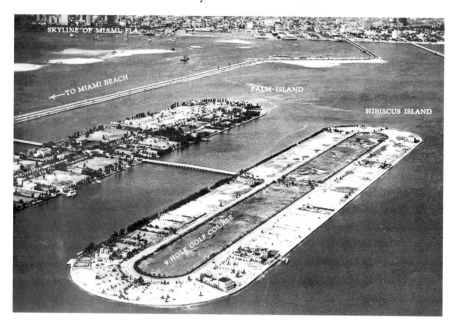

The original photograph made for the Biscayne Bay Islands Company by Richard B. Hoit shows Hibiscus Island closest to camera, with the golf course planned for the center of the island. Palm Island is to the left; County Causeway, the beginnings of Watson Island and the Miami skyline are in the background.

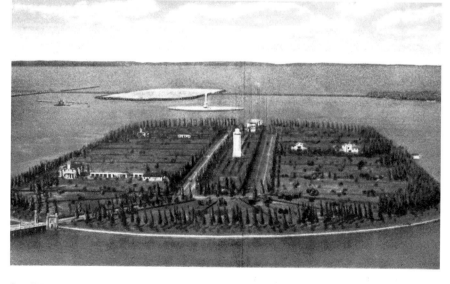

Star Island, complete with water tower, circa 1927. Flagler Monument is in the background, as is one of the Venetian Causeway islands.

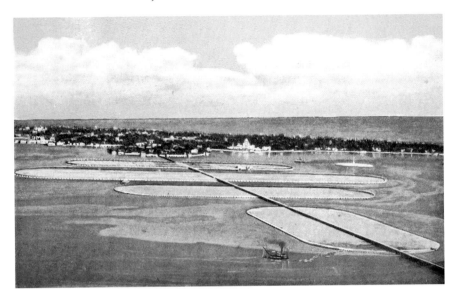

An incredible view of the newly pumped-in Venetian Islands has Belle Isle in the background, with the Flamingo Hotel to the right. This view looks toward Miami Beach.

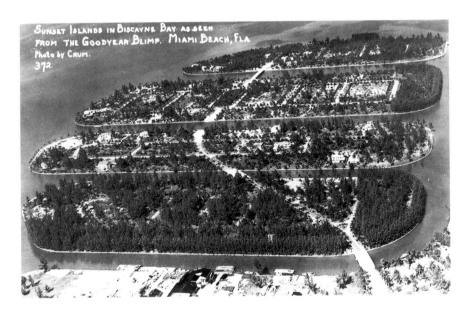

The four Sunset Islands from the Goodyear blimp, showing the Alton Road/Purdy Avenue entrance, circa 1930.

The Story of Miami Beach

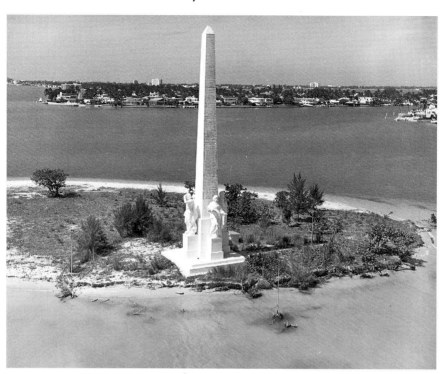

Above: The magnificent Flagler Memorial Monument on Monument Island. This Chris Hansen photograph was made on February 19, 1969, and was one of the catalysts to awakening the city to the fact that the island was being washed away. Fortunately, the city reacted in time and has extended and bulkheaded the island, now caring for it and preserving the nation's single greatest monument to Florida's Empire Builder, as it should always have done.

Right: The beautiful fountain on Normandy Isle. Seventy-first Street has been renamed Henri Levy Boulevard to honor the man who built Normandy Isle and without whose efforts the Seventy-ninth Street Causeway would not have been built until much later.

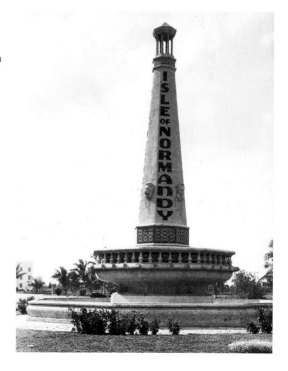

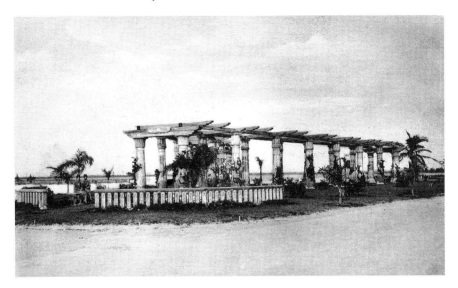

An incredible view, somewhere on Normandy Isle, likely made by Levy himself and quite possibly showing his wife, Rose, and older daughter, Clemence, seated at left. The structure is so long gone that nobody alive today in Greater Miami has any recollection of when it was built, where exactly it was or what its purpose was.

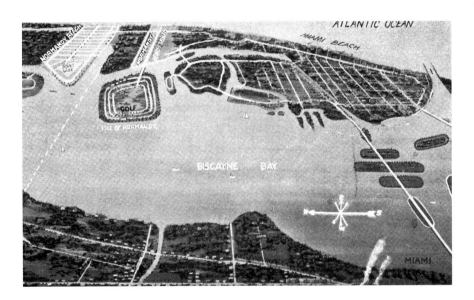

This postcard was issued by Henri Levy's Normandy Beach Properties to show Normandy Isle (diamond-shaped island at left), as well as his projected causeway, noted by the dotted line at far left. Although not to scale or correct as to shape, several other Biscayne Bay islands are recognizable.

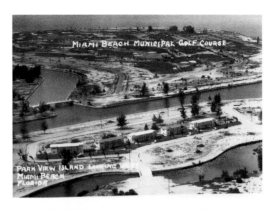

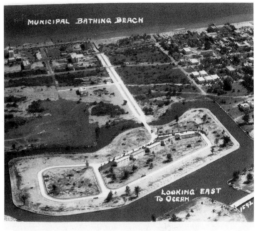

Right: Two views of Parkview Island, reached via the bridge at Seventy-third Street and Dickens Avenue. The upper view shows the island, in the foreground, and looks west toward Normandy Shores, where the city's north end municipal golf course is. The lower view looks east toward the Atlantic; much of the swampy area in front of the island has yet to be compacted.

Below: A spectacular aerial view of all of the city's north end islands. From the left are the Stillwater Drive peninsula, Biscayne Point, Normandy Shores, Normandy Isle and LaGorce Island. Behind (to the east of) LaGorce is Allison Island.

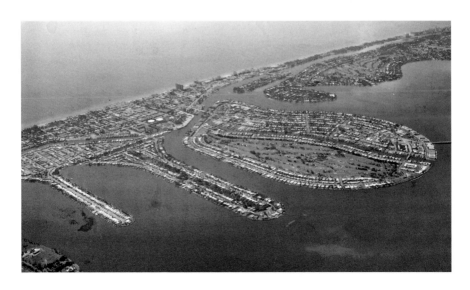

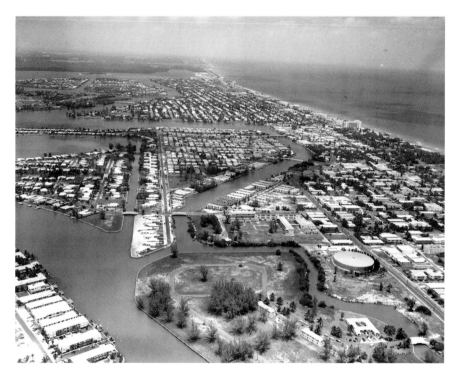

Looking north from above Parkview Island, a piece of Normandy Shores is at the immediate left, part of Biscayne Point to the left beyond. The two bridges from Seventy-seventh Street to Biscayne Beach (directly in the center of the photograph) are clearly visible, and Biscayne Elementary School is on Seventy-seventh Street to the right of the first bridge. The city's north end reservoir is at right. Both photos were taken on May 24, 1954.

CHEESECAKE... CHEESECAKE...AND OTHER PRETTY GIRLS

Cheesecake! Man, do we love cheesecake! But which cheesecake? The beautiful girls lolling against the palm trees, running down the beach or posing in their bathing suits so the photographers hired by Fisher's publicist, Steve Hannagan, could shoot them for northern newspapers in the dead of winter in the 1920s and '30s? Or the confection-like dessert that helped make Al Nemets' Coffee Shop, Joe's Broadway, DuBrow's, Wolfie's, Junior's, Pumpernik's and Rascal House famous? And which cheesecake—or slice thereof—did we love the most? Plain? Strawberry? Blueberry? Chocolate marble? Cherry? Did it make any difference? We couldn't wait to finish dinner and have a piece!

Miami Beach's reputation was made in the early 1920s when Hannagan hit upon the idea of having beautiful young women in the glamorous bathing suits of the time smile at the camera in seductive poses. Once the film was developed, Hannagan would send the pictures by wire service in the dead of winter to every newspaper in the country east of Denver (the St. Louis–San Francisco Railway, along with its partners, the Southern Railway and the Florida East Coast, operated, for many years, the famed passenger train "Kansas City–Florida Special") with cut lines such as "It's always June in Miami Beach" or "Turalura Lipschitz and her twin sister Tondalaya are in Miami Beach enjoying seventy-eight-degree sunshine on December 21st!" or "Myrna Meyers, Madi Bergman, Joyce Schrager, Marsha Gildenberg, Jessica Brothers and Joyce Cohen are basking in the sun every day of their Miami Beach vacation!" And it worked!

Northerners and midwesterners, tired of the cold, worn out from the strain of fighting snowstorms, sleet and blizzards and made wide eyed by the beautiful girls in bathing suits in the Hannagan-posed photos began pouring into Miami and Miami Beach. To no small extent, Fisher's success selling Miami Beach can and should be credited to Steve Hannagan.

Hannagan, for whatever reason, dubbed the beauties in their poses "cheesecake," and the name for lanky, doe-eyed swimsuit and swimwear models of the female persuasion promoting Miami Beach has, ever since the 1920s, remained "cheesecake."

But there is, as noted earlier, another kind of cheesecake, one that men, women and children can sink their teeth into and simply not believe that anything could possibly taste *that* good. There were no contests held to see which of the great Jewish-style (but not Kosher) restaurants had the absolute best cheesecake because they were *all* that good, and each of the eateries had its aficionados and die-hard boosters. Even in Rascal House's last days as the last of the great mini-Danish on the table for breakfast/wonderful rolls, sauerkraut, sour tomatoes, coleslaw and real Kosher dill pickles on the table at lunch and dinner restaurants, Miamians, visitors and tourists still went for the cheesecake, if, sadly, for nothing else.

While the times, as always, are a-changin', the purpose of this book is to keep the memories of those great days, great people and great places alive. And, in the case of this chapter, when it comes to the cheesecake of the restaurants we so lovingly remember, the taste!

Shown in all its glory, a piece of Pumpernik's cheesecake is at top, with an almost as good, but not as often ordered, piece of chocolate cream pie below. The placement of the cheesecake on this Pumpernik's advertising card is indicative of the culinary heights at which the cheesecake was held!

Right: Mr. Pumpernik greeted his guests at Sixty-seventh Street and Collins, across from the Deauville and, later, in other locations, but the Miami Beach store, with the marvelous retail bakery attached and owner Charlie Linksman's sister-in-law, Goldie, managing it, was extra special.

Below: Laura Jamieson, director of Miami Beach Botanical Garden, whose warmth and graciousness add immensely to the Garden. *Courtesy Miami Beach Botanical Garden*.

6700 COLLINS AVENUE - MIAMI BEACH
126th STREET AND BISCAYNE BLVD. - NORTH MIAMI

This page: Whether utilizing Fisher's famous elephant, Rosie, as a backdrop for the girls loading Miami Beach coconuts tagged for shipment all over America or posing in front of or on a Lummus Park beach bench, the intent was the same: show Americans not only how gloriously beautiful Miami Beach was but also, above all, how it was the place where summer spent the winter.

This page: The styles, swimwear fashions and hairdos changed over the years, but the intent didn't. Whether it was Steve Hannagan as Fisher's promotions director or Hank Meyer (for whom Seventeenth Street on Miami Beach was renamed) as the city's publicity and public relations director, the beautiful young women still invited Americans to join them on Miami Beach.

They were all beautiful, but especially the ladies! From the left are Miami Beach hotelier Irving Pollack, wife Marcella, Irving's brother Lou and Lou's wife, Elaine. *Courtesy Darryle Pollack.*

In an as close to a cheesecake pose as it gets, the ladies at Sydelle and Quentin Sandler's December 31, 1949 New Year's Eve party kick up their heels. From the left are Eleanor Katz, Joy Gettis, Jean Iver, Selma Grenald, Mimi Kobley and Sydelle. *Courtesy Quentin Sandler.*

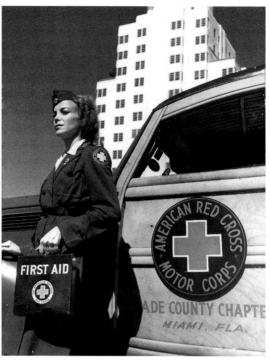

Lucille Freeman was leader of the Miami Beach women serving in the Red Cross Motor Corps in Dade County during World War II. Shown here on August 1, 1942, with a station wagon that was used as an ambulance, Freeman aided and assisted survivors of ships torpedoed by German U-boats and volunteered in other capacities during the war. *Courtesy Ron Silvers, Bill, Bob and Frances Nefsky.*

Though Bill Cohen does look pretty good, wife Martha, with her wonderful smile, is as gorgeous as ever. This photo was taken at a wedding at the Cuban Hebrew Congregation on Normandy Isle in May 1987. *Courtesy Lawrence Gaisin.*

Charming and delightful, Sherry Roberts is shown during her campaign for Miami Beach City Commission.

The girls didn't get much prettier than Wendy Sue Unger, Beach High grad, daughter of Caryl and Dr. Harold Unger and sister of Dr. Stephen and CPA Arthur, all longtime Miami Beach people. *Courtesy Caryl and Dr. Harold Unger.*

THE 'BURBS

Though it is often hard for people to differentiate, and even though they are usually considered part of Miami Beach, the six municipalities to the north and the one to the west are separately incorporated from Miami Beach, each having its own municipal government.

Starting at the far north end of the beach side of Biscayne Bay is the town of Golden Beach, made up entirely of single-family homes, with no apartments or businesses. The city of Sunny Isles Beach is next, having created a park—and named it for the original area's founder—to encompass the only mangrove preserve still in existence on the east side of Biscayne Bay. Haulover Beach, the county park, and Haulover Cut separate Sunny Isles Beach from Bal Harbour Village, home of the shops of the same name. Bal Harbour is contiguous with the town of Surfside, which will celebrate it's seventy-fifth anniversary in 2010, and both connect to the town of Bay Harbor Islands—founded by Ruth and Shepard Broad and Benjamin Kane, with partners Max Orovitz and Dan Ruskin—via a bridge over Indian Creek. Indian Creek Village, an enclave of magnificent residences and a highly rated golf club and course, is reached by bridge from Surfside.

North Bay Village (NBV) is reached via Normandy Isle and the east Seventy-ninth Street (John F. Kennedy) Causeway bridge. Made up of two islands, NBV is a mix of hotels, dining spots, office buildings, Channel 7 television station, high-rises and private homes. Like the other six villages, towns and cities, NBV is a highly desirable place to live or work.

Each of the municipalities carries its own memories, from Golden Beach's exclusivity (not necessarily due to restricted covenants in deeds but because it was intended for and remains as an enclave of single-family residences) to Sunny Isles Beach's (formerly Sunny Isles) motel row, to Bal Harbour's and Indian Creek Villages' restrictions on who was allowed to

buy homes or stay in Bal Harbour's hotels (all of that thankfully long past) to Surfside's wonderful shopping area, as well as beautiful private homes throughout the town.

Although much has changed, NBV is remembered as the location of the Buccaneer, Chimney Corner, Dean Martin's, Oby's, Fun Fair, Luau, Dairy Queen, Beach Bowl, the Bonfire, Chary's, Place for Steak, the Penthouse and Harbor Island Spa. What grand and glorious memories, filled with mostly happy days!

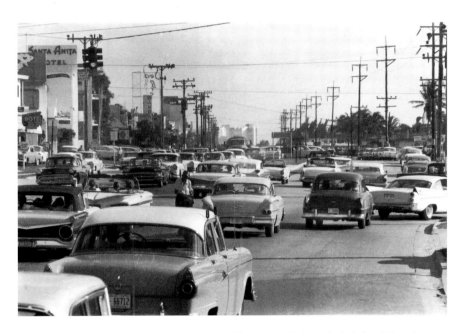

Sunny Isles, looking south on Collins Avenue, March 25, 1959, at the height of the winter season. The Santa Anita and Mandalay Motels are visible on the left, with several of Bal Harbour's high-rise oceanfront buildings in the distance. For a complete history of Sunny Isles Beach, the reader is referred to *From Sandbar to Sophistication: The Story of Sunny Isles Beach*, published by The History Press and available from the publisher or online.

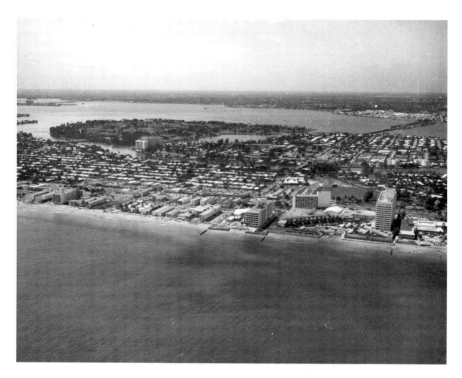

An aerial view of the 33154 zip code, circa 1961. At right is Bal Harbour and the Singapore Motel, with the Americana Hotel at center right. Surfside is to the left of the Singapore, with Bay Harbor Islands directly across Ninety-sixth Street at center. Indian Creek Village is the island at the left. For more information on, and the histories of, the four communities that encompass the 33154 zip code, *33154: The Story of Bal Harbour, Bay Harbor Islands, Indian Creek Village and Surfside*, also published by The History Press, is highly recommended.

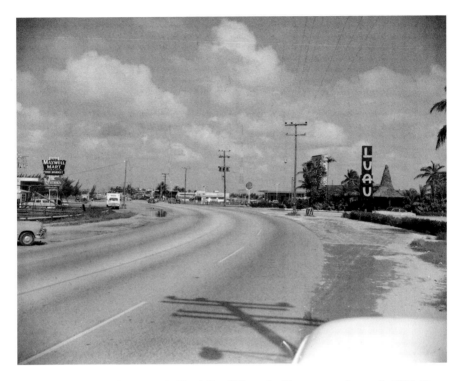

Seventy-ninth Street Causeway in North Bay Village, looking west on August 1, 1958. On the right are the Luau and a Gulf station with Fun Fair behind that. On the left is Maxwell Mart, replaced a year later by Dairy Queen, and the Beach Bowl "Bowling" sign.

THE GALBUT FAMILY

They are an incredible family. The only real difference between the Galbuts and some of the other early pioneering Miami Beach families is that the Galbuts were always low key, neither asking for nor accepting kudos for their great and charitable works. They are a family of doers and helpers, and their mantra is now and has always been kindness to others.

Hyman P. Galbut was born in the Bronx in 1920 and relocated to Miami Beach with his father, Abraham Al, his mother, Bessie, brother Paul and sister Miriam. Abraham Al located his business—a restaurant and all-night cafeteria known as "Al's"—on the southwest corner of Fifth Street and Washington Avenue. Abraham Al Galbut became known as the mayor of south beach and was referred to by that title from the early 1930s until he died in 1950.

When Hyman and Miriam were old enough, Abraham Al turned over the management of the Miami Beach Auto Tag Agency to them. That business not only was the first tag agency on Miami Beach, but it also provided driver's licenses, which, at that time, could be obtained from licensed and bonded vendors.

Following graduation from Miami Beach High in 1938, Hyman left for New Orleans to attend Tulane University. It was while he was going to school there that he met Bessie Dulitz, who was then sixteen. Bessie's father, Morris Dulitz, met Hy in synagogue and brought him home for Shabbat lunch following services, expecting that he would enjoy meeting Bessie's older sister, Leah. Although he exchanged pleasantries with Leah, he was enchanted by her younger sister, and it would be Bessie with whom he would fall in love.

Prior to his marriage to Bessie on August 11, 1946, Hy entered the U.S. Navy and was sent to the Pacific for action during World War II, spending

several years there. He would remain in the navy, both active and reserve, for thirty years, retiring only after he reached the lofty rank of captain.

After marrying Bessie, he attended law school at the University of Miami, obtaining his law degree in 1952 in the company of such noted Miamians as federal bankruptcy judge A. Jay Cristol; Albert Weintraub, grandson of Isidor Cohen, Miami's first permanent Jewish settler; and the late Arthur Nemser, son of Dr. Abraham Nemser and longtime beach resident.

Bessie and Hyman were blessed with four sons, all of whom are eminently successful in their own rights. Son Robert Nathan, married to Rita, is a pulmonologist, while brother David Lewis, married to Gita, is a cardiothoracic surgeon. Abraham (also known as Albe) is married to Nancy and is a practicing attorney. Albe is active in real estate, while his brother Russell, who is married to Ronalee, is managing principal of Crescent Heights, a condominium and real estate development firm. Russell and Ronalee's beautiful (like all the Galbut children) daughter, Marisa Anne, married Daniel Newman in Miami Beach on Tuesday, June 23, 2009, in an elegant Orthodox ceremony.

In his long and incredibly productive life, Hyman Galbut was a giver and a doer, serving Jewish causes and the people of his city. He was president of such organizations as Mt. Sinai Cemetery, the Hebrew Academy (of which he was a founding father and which all four of the Galbut sons attended and graduated from with honors), Beth Jacob Synagogue and Beth Israel Synagogue. Providing an inordinate amount of pro bono legal services to those who were indigent or otherwise unable to afford legal representation, Captain Galbut was a pluperfect example of what the legal profession should be about.

With all of that, Galbut served on numerous city advisory committees and boards, including the Miami Beach Health Advisory Board. He further served the city as a councilman and vice-mayor in the early 1960s.

It would be difficult for the Galbut son's mom, Bessie, to be prouder, but her pride is understandable when it becomes known that she has numerous grandchildren and great-grandchildren living in the area, with all four of her extraordinary sons living in proximity on Miami Beach.

While the occupations of the Galbut men are noted above, the community owes a debt of special gratitude to Russell, who, along with all of his other duties and his responsibilities as managing principal of Crescent Heights, one of America's premiere condominium companies, oversees the Plaza Health Network of nursing homes and adult congregate living facilities, including the Hebrew Home for the Aged on Miami Beach.

Hyman Galbut died on January 29, 2006, leaving a legacy of love, kindness and caring to Bessie, his four sons, his grandchildren and his

great-grandchildren, and he will be remembered always for his warmth and compassion. The Galbuts, one of Greater Miami's most outstanding families in every positive way possible, should be forever memorialized for all that they have done to help to improve schools, religious education and philanthropy, benefitting, literally, thousands of people, and all of it done without anticipation or expectation of remuneration or even gratitude; rather, they do it because giving back to the community is what the Galbut family is all about.

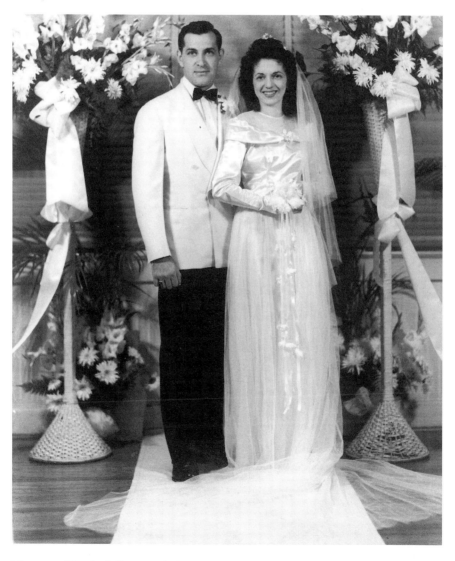

Hyman and Bessie Galbut, married August 11, 1946.

Hyman as a young naval officer. He would eventually earn the rank of captain.

Bessie and Hy's sons, Abraham (Albe) and Russell; the boys look to be about sixteen years old.

From the left are Hyman, son Dr. Robert and grandson Brian.

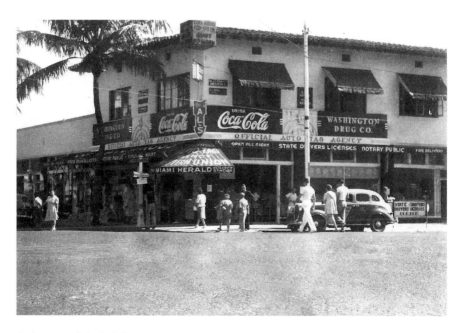

A close-up of the building housing Al's, the signs advising passersby of the availability of driver's licenses and auto tags prominently displayed, clearly shows the second floor, where Hyman would eventually have his law office. Downstairs, in Al's, the kids, after a great hamburger and a Coca-Cola at the lunch counter, would while away too much time on the pinball machines.

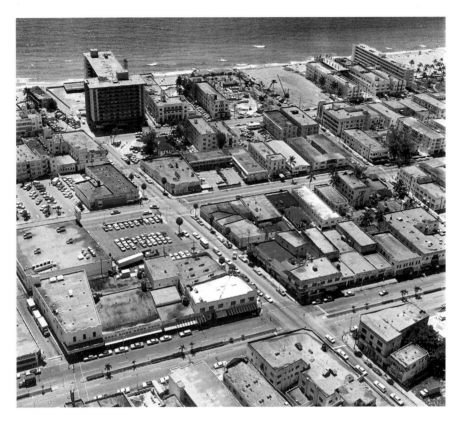

Taken by Chris Hansen on August 1, 1969, this photo looks directly down at Fifth Street, running east toward the ocean, and Washington Avenue, the wide street with the median running from left to right. The building housing Al's Restaurant, as well as Hyman's law office, is visible on the southeast corner of Fifth and Washington. Across the street, the white-roofed building was home to both Miami Beach Drugs and the Fifth Street Gym.

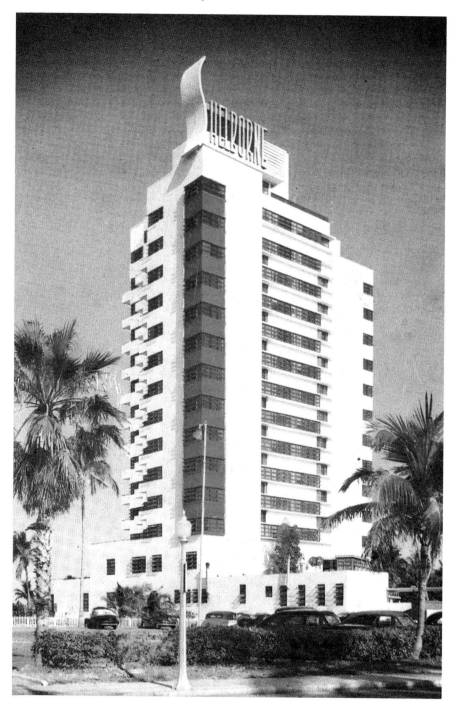

Hyman's other pride and joy, the beautiful art deco Shelborne Hotel at Eighteenth Street and Collins Avenue.

ABOUT THE AUTHOR

Seth Bramson is Miami's foremost and leading historian. A Miami-area resident since 1946, he is the country's most published Greater Miami history book author; eleven of his sixteen books deal directly with the villages, towns, cities and people of Miami-Dade County. This, his seventh book with The History Press, is his second dealing with the history of his hometown, Miami Beach. In addition to his books, he has written and had published more than seventy articles, including three in refereed or juried publications.

The senior collector of Florida East Coast Railway memorabilia, Florida transportation memorabilia, Miami memorabilia and Floridiana in the country—referred to as "the grand poobah of Miami memorabilia collecting" by no less a personage than a former editor of the now defunct *Miami Daily News*—he is known in south Florida as "Mr. Miami Memorabilia." His collection of Miami memorabilia and Floridiana is the largest such collection in private hands in America.

A graduate of Cornell University's famed School of Hotel Administration, he holds master's degrees from St. Thomas University and Florida International University, both in Miami. He is adjunct professor of history at both Barry University, where he is historian in residence, and at FIU, where he is historian in residence at the University's Osher Lifelong Learning

Institute. Additionally, he is on the faculty of the Nova University Lifelong Learning Institute.

He is now working on three more local histories, and longer-range plans call for books on the history of Florida's street and electric railways and the history of the Florida East Coast Hotel Company, one of the entities of the Flagler System.

The company historian of the Florida East Coast Railway, he is one of only two people in the country who bears that official title with an American railroad.